Praise for *Make It Mem* and Bob Dotson

"Bob Dotson writes blueprints. He's the architect of stories you'll remember the rest of your life, whether you encounter them on NBC's *Today Show* in his long-running series *American Story with Bob Dotson*, his award-winning books, his websites, his in-person workshops and even his absorbing conversations. Sometimes you will encounter Bob Dotson's writing on the page or computer screen. Other times you will experience his writing as stories translated into sounds and images for television. That's the magic of a multidimensional writer who knows how to fashion a compelling story, whatever the medium. Bob reveals how he does it in this book, and how you can make your own work just as memorable and distinctive. Talk about a head start on the competition."

—Professor Frederick Shook,
author of *Television Field Production and Reporting*

"The power of the written word is alive and well!

That's what I think when I watch one of Bob Dotson's stories. He is a craftsman who blends fascinating subjects with dramatic images and thought-provoking words. The result is a story that grabs and holds a viewer's attention.

In this age of rapid-fire events and 'get it on the air now' coverage, Bob's work stands out as artistic and mature. The perfect combination of information and intelligence.

Read this book. Learn from a master."

—Matt Lauer, co-host, the *Today Show*

"Want to be another Bob Dotson? Don't. Only Noah wanted two of a kind. As good as Bob is, the world is content with one Bob Dotson. But the broadcasting world does need more reporters with Bob's ability to tell stories. Not *tall* stories. Short stories. True stories. Good stories.

As a storyteller, Bob excels. He knows how to tell stories simply, clearly, skillfully. He tells them on NBC News. Often they're not spot news. Or hot news. Or hard news. But he can make them news.

And Bob knows how to tell other pros *how* he does it. So a good way for newbies, oldbies and wannabes to improve their skills is to see Bob Dotson, hear Bob Dotson and now, *read* Bob Dotson.

You can't get ready for prime time by going through one book, taking one course, attending one workshop, or even doing all those things. There's more to writing than that. But if you mean business, if you're all business, you *can* become a far better storyteller.

In this book, Bob tells how—how he approaches a story, how he avoids the herd, how he thinks for himself. So if you want to find out how, here's a good place to learn some lessons. But don't try to *be* Bob Dotson. And don't try to be a copy. Be an original."

—**Mervin Block**, writing coach

MAKE IT
MEMORABLE

MAKE IT MEMORABLE

WRITING AND PACKAGING VISUAL NEWS WITH STYLE

SECOND EDITION

BOB DOTSON

ROWMAN & LITTLEFIELD
Lanham • Boulder • New York • London

Published by Rowman & Littlefield
A wholly owned subsidiary of The Rowman & Littlefield Publishing Group, Inc.
4501 Forbes Boulevard, Suite 200, Lanham, Maryland 20706
www.rowman.com

Unit A, Whitacre Mews, 26-34 Stannary Street, London SE11 4AB, United Kingdom

British Library Cataloguing in Publication Information Available

Library of Congress Cataloging-in-Publication Data

Dotson, Bob.
 Make it memorable : writing and packaging visual news with style / Bob Dotson. —
Second edition.
 pages cm
 Includes index.
 ISBN 978-1-4422-5610-1 (cloth : alk. paper) — ISBN 978-1-4422-5611-8 (pbk. : alk.
paper) — ISBN 978-1-4422-5612-5 (electronic) 1. Television broadcasting of news.
2. Online journalism. 3. Reporters and reporting. I. Title.
 PN4784.T4D68 2016
 070.1'9—dc23 2015022614

♾️™ The paper used in this publication meets the minimum requirements of American
National Standard for Information Sciences—Permanence of Paper for Printed Library
Materials, ANSI/NISO Z39.48-1992.

Printed in the United States of America

To Linda

my lifelong partner
since "I do"

BRIEF CONTENTS

Detailed Contents	ix
Chapter 1: How to Become a Storyteller	1
Chapter 2: The Game of What If?	17
Chapter 3: Getting Started	55
Chapter 4: I'm Sorry This Story Is So Long. I Didn't Have Time to Write a Short One.	83
Chapter 5: The Building Blocks of a Story	103
Chapter 6: A Survival Kit for Professional Storytellers in the Social Media Age	119
Appendix: Reporter's Checklist	129
Glossary of Script Cues	131
Acknowledgments	133
Index	135
About the Author	141

DETAILED CONTENTS

Brief Contents vii

Chapter 1: How to Become a Storyteller 1

Reporting vs. Storytelling 3

The Rule of Threes and Filling the Silence 4

The Question That Is Not a Question 4

Script #1: Lives Lost 6

The Most Important Thing You Should Do Before an Interview 13

The Best Thing You Can Do After an Interview 14

How to Quickly Write a Good Opening Line 14

Chapter 2: The Game of What If? 17

Hey. You. See. So. 17

Script #2: Pops Dream 18

Surprises 28

Script #3: Farm to Fame 29

Humor 39

Structuring a Visual Story 39

Planning Notes for YouTube Star Segment 40

What Went on the Cutting Room Floor 44

Script #4: YouTube Star 45

Chapter 3: Getting Started 55

Look for Different Ways to Tell Your Story 55

Script #5: Found Art 56

Find a Strong Central Character 63

Script #6: Park Avenue Peeler 64

Find Interesting Stories and People to Interview,
Even When Time and Money Are Tight 72

Script #7: Living Ghost Town 73

Chapter 4: I'm Sorry This Story Is So Long. I Didn't Have Time to Write a Short One. 83

Pictures Come First 83

Write the Middle of Your Story Next 84

Ask Yourself, "What Does This Story Mean?" 84

Don't Throw Away Thoughts 84

Script #8: Cave Rescue 85

Highlight a Story's Natural Drama 88

Working Fast 89

Script #9: Ruby Bridges 89

Scene Setting 96

Foreshadowing 98

Conflict 98

Character Growth 98

Resolution 99

Put Stories into Context 99

Chapter 5: The Building Blocks of a Story 103

Words 103

Video 104

Silence 104

Natural Sound 104

Sound Bites 105

Reporter On-Camera Stand-Up 105

Graphics 106

Script #10: Pearl Harbor's Untold Story 107

Editing Stories 117

**Chapter 6: A Survival Kit for Professional Storytellers
in the Social Media Age** 119

The "So What?" Test 119

"One Thing Is Certain . . ." 120

You Are Not the Story 120

It's Video, Folks, Not the Movies 121

Be Conversational 122

Gobbledygook and Clichés 123

Active Voice 123

Write in Threes 124

How to End a Story 124

Car Wars 125

A Final Thought 128

Appendix: Reporter's Checklist 129

Glossary of Script Cues 131

Acknowledgments 133

Index 135

About the Author 141

CHAPTER I

HOW TO BECOME
A STORYTELLER

T HERE are many books that will teach you the nuts and bolts of new media—how to use the tools; how to write and perform. This little book reveals something more basic: how to master the timeless techniques of telling better visual stories. They haven't changed since the first reporters saw someone take on a dinosaur. Those ancient storytellers scrambled back to their caves, painted pictures on the walls and said, "Wow, you should have seen the size of that sucker!" Everyone had access to the same information. The best storyteller had a packed cave.

I joined NBC News back when the earth was cooling. Not long after those dinosaurs. During my long career, I've worked hard *not* to become a dinosaur myself. Learned to shoot and edit video, blog, vlog, tweet, pin and post. All day. Every day. Just another challenge in a job that is endlessly fascinating. What have I done? I've been an investigative reporter, covered politics and breaking news. Shot documentaries. Ducked bullets reporting wars. Spent months trying to solve murders. Been to more natural disasters than I can count. Now I report the *American Story with Bob Dotson*, my signature segment on the *Today Show*.

This is long-form reporting, but I still work under tight deadline, rough edit video in the field and shoot some of my own story elements for the *American Story* web page. At the first station where I worked, we all carried cameras. Even the anchor people and news director were expected to shoot and edit stories. Like skinny ties, everything comes back into fashion.

We learned how to manage our time. Today, when I'm working on *American Story*, I approach the assignment like an artist painting with oils. If I'm covering spot news, I "paint" with watercolors, splashing three or four vibrant scenes that will engage an audience. You will run out of time if you use long-form tools on a quick turnaround story.

Throughout my career, the job has constantly changed. All those cutting-edge gizmos we had when I started are now in a museum. Typewriters. Film cameras. Hot splicers. Yes, we have to master ever-changing technology. Yes, we have to tell our tales under ever-tightening deadlines. But more importantly, we must master the classic techniques of telling better stories. The basic devices remain: *reporting* and *storytelling*. They are two sides of the same coin. Reporting is what you do to get a great story, but stories are remembered only if you tell them well. Reporters learn to gather facts. Storytellers weave those facts into a fabric that covers the subject while enticing us to know more.

There's a big difference between a reporter and a storyteller. I start every story assuming that nobody cares about anything I'm going to tell. That forces me to find the universal themes that will interest the greatest number of people. Everybody likes to laugh, but the best comedians can make a four-year-old giggle and an eighty-year-old, too. Talent alone won't do that. Curiosity and imagination make you a better storyteller.

A friend of mine used to moan, "I can't write." He's a wonderful storyteller with pictures, but words frighten him. He once covered an all-night concert. I joined him in the morning.

"Anything going on?" I asked.

"Not much," he answered. "Breakfast was either smoked or passed around in a bottle."

I grinned. "Bet you got pictures of that."

"Yep."

"Well," I chuckled. "Thanks for my opening line."

"Huh?"

"'Breakfast was either smoked or passed around in a bottle.' I think that kind of sums up this party, doesn't it?"

"Well . . ."

"Thanks," I said. "You're a helluva writer."

Whether your specialty is sound or picture or words, ultimately your task is the same as the guy who sat around a campfire two thousand years ago and told about his hunt. We're still trying to tell our stories in ways that people will want to hear them. So, don't get hung up on a job description. When people ask me what I do for a living, I say, "Storyteller."

Writing—good writing—lasts.

One of the most powerful lines ever scribbled is as old as the Bible.

"Jesus wept."

Subject. Verb.

Not, "Jesus, a carpenter from Nazareth, age 30, was executed in the pre-dawn darkness . . ."

Just, "Jesus wept."

Tight writing like that is essential for our visual medium, which needs sentences strong enough to push the story along, but short enough to leave plenty of room for natural sound and pictures.

REPORTING VS. STORYTELLING

Unfortunately, some in our business now see storytelling and reporting at odds with each other. A news correspondent told me:

> *"We don't have to tell stories well today. We just report what's happening as fast as we can."*
>
> "What was the last thing you tweeted?" I asked.
>
> *"The suspect went to the mall and bought a green sweater."*
>
> "Okay, same number of letters, 'Mister the gutter ain't a step up from you.' Which tweet tells a story?"
>
> She grinned.

That's a line that grabs attention. If you want to get paid on Friday, you have to do more than a play-by-play of the news.

"But life is too busy for thoughtful writing. It's unfair to expect more."

My daughter's fourth-grade teacher, Mrs. Boehme, used to tell her students: "Life is unfair or my husband would have hair." Stop worrying about what you don't have time to do. This book will help you become a

more efficient storyteller and give you more time to polish what you present. The chapters are filled with tips to help you work faster and smarter. These are not my ideas. They are lessons I've learned from watching the most successful people in this business.

THE RULE OF THREES AND FILLING THE SILENCE

I've done thousands of interviews in my career and have noticed a pattern to people's responses. They nearly always answer the question three times. First, they tell you the answer they want you to hear. Second, they explain their answer. Third, they blurt out a sound bite—if you wait a beat before jumping in with the follow-up question. Let the silence grow. Silence makes people uncomfortable. They suspect you still don't understand their answer. That's when they put their thoughts into sharp focus.

Uncomfortable silence helps you get more memorable, shorter quotes. And yet, what's the one thing we don't do in this age of live shots? We *never* stop talking. That's why we end up relying on professional speakers—lawyers, pundits and politicians—people who can give us the sound bites we expect, even if we interrupt them. The problem with that: Everybody gets the same sound bites. Often predictable. Sometimes boring.

THE QUESTION THAT IS NOT A QUESTION

How do you get unique quotes? Try asking the Non-Question/Question. I learned this trick from a photojournalist named Scotty Berner, who used the technique to scoop the world. A dozen of us were staking out the home of a young pilot in Lubbock, Texas. The boy's father was the leader of the Iranian government at the time, a dying king who had just been deposed. Everyone wanted to record a sound bite from his son. Only Scotty got it, simply by asking a question that was not a question.

The young pilot was going to school in Lubbock. He lived off campus, his home heavily guarded. The boy was never seen. Stakeout crews sat day after day. Just before sunset one evening, Scotty saw a young man walking down the street who didn't look like he grew up in west Texas.

Scotty shouldered his camera. Quietly stepped away from the gaggle of newspeople. Wandered down to talk to the boy. He noticed the guy was looking at flowers.

Scotty spoke softly as he approached, so the rest of us couldn't hear the conversation. "Aren't those beautiful lilies?"

The young man answered, "Yes, they really are."

Then Scotty turned on his camera and said, "I used to work in a flower shop before I became a newsman."

Now, the boy knew for sure what must have been obvious: Scotty was a reporter. But so far, they were simply talking about the flowers.

Watch what happens, though, as they continue to talk. Scotty subtly steers the conversation to the subject of fathers.

"My dad used to love flowers."

The young man said, "Yeah, my dad loves flowers too."

Scotty looked at the lilies and added quietly, "My father died two years ago after a long illness," which was true.

That prompted the young man to say, "My dad is real sick too."

Now here comes the trick—the Non-Question/Question. Scotty said softly, "I miss my dad."

"Me too," the young man answered, lost in thought.

Scotty let the silence build between them. Finally, the man looked up at the camera and in the next ten seconds gave Scotty an exclusive, unique sound bite, even though no question had ever been asked.

"My father will be taken to Panama. He is a man without a country. It is so sad."

Scotty still didn't know for sure if the man was the king's son, until a couple of minutes later when a bodyguard bobbed up over a hedge, noticed the two of them and started shouting.

"He's out! He's out!"

Half a dozen guards ran down the driveway.

Scotty knew better than to start arguing First Amendment freedom with guys who were carrying their Second Amendment freedom. Instead, he simply turned his camera on them, shooting the pictures he'd need to set up the quote from the king's son.

Scotty had beaten all of us to an exclusive without ever asking a question.

Later, he explained how he did it:

"With the Non-Question/Question, you put people at ease. Talk about what's going on in their lives. Then gradually bring the subject around to the topic you want to discuss."

Instead of jumping out of the truck, breathlessly waving microphones at people, simply walk up and say, "Hi, I just want to introduce myself." If the moment is emotional, apologize for intruding. If the story subject is busy, talk about what he's doing. Find common ground. "Hey, I painted my house last year, too."

SCRIPT #1: LIVES LOST

Here is an example of what those three techniques can produce, a story about four little girls shot dead in a Jonesboro, Arkansas, schoolyard. This tragic event had been covered like breaking news for days. I thought it was time to remind viewers that there was more to this tale. Looking at a school yearbook one day gave me an idea: get children together to talk about their classmates.

We had to carefully lay out the images that would accompany our story. Video of the shooting ended up on the cutting-room floor. Why not use those powerful pictures? Our focus would be the lives of those children who died, not how their lives ended. Besides, those images had been overused. They'd become like faded wallpaper. Look for more pictures that have not been seen. The best way to find them is to ask the question that is not a question.

Note: It is standard to use a two-column format in all television news scripts. The left column includes all the visual cues, while the right column provides the audio cues. Here and in the other scripts provided in this book, you will see a three-column format with visual cues in the left column, audio cues in the center column and a third column at the right featuring story tips and behind-the-scenes commentary.

ANCHOR INTRODUCTION:
Murder puts some places on the map, as unfair as that is. Everyone now knows where Jonesboro, Arkansas, is. And what happened there. But something got lost in our reporting. We told you little about the girls who died. They became—simply—tragic symbols of what can go terribly wrong. They were more than that, of course. Here's NBC's Bob Dotson.

CLASSMATES OF THE DEAD STUDENTS SITTING IN AN OLD GYM BUILT DURING THE 1920S. THE KIDS ARE THUMBING THROUGH YEARBOOKS.

We open with kids looking through yearbooks because those images foreshadow the story to come.

A YOUNG BOY ASKS HIS CLASSMATE:

NAT SOUND: "What grade was she in?"

Watching them close those yearbooks inspired the line that matched the first pictures.

[NARRATION]
Sometimes the yearbook of life closes too soon.

Sound recorded on location as part of the video action is called natural sound [NAT SOUND].

BOY POINTS AT PICTURE IN BOOK.

NAT SOUND: "Here's Britthany [*sic*] Varner."

BLACK AND WHITE PHOTOS OF GIRLS	**[NARRATION]** **We are left with grainy pictures and long-lens grief.**	*The yearbook photos were poor quality so I turned that into a story point, underscoring what little we knew about the girls, reporting their stories from afar.*
BOY LOOKS UP FROM YEARBOOK.	NAT SOUND: "It's just weird they were the ones to die."	
MORE PHOTOS IN YEARBOOK	**[NARRATION]** **No way to measure a loss.**	
ANOTHER BOY'S VOICE HEARD OVER THE GIRLS' PHOTOS	NAT SOUND: "They were probably the nicest kids in the school."	
LAYERED SHOTS OF CRIME SCENE, GRAVES AND FLOWERS	**[NARRATION]** **The four little girls who died in that Jonesboro schoolyard were more than what happened to them. They were small-town kids with barefoot voices—a lot like these.**	*This paragraph states the theme of our story. Listen to the children talk. Every now and then a yearbook picture makes them giggle. You'll hear glimpses of happier times. The words "barefoot voices" underscore that.*
GIRLS' PHOTOS— MIXED WITH THEIR CLASSMATES' VOICES	(STEPHANIE) "She was a kind-hearted person and she cared about people." (PAIGE) [*sic*] "She was a good basketball player and volleyball player."	

STUDENT COLBY BROOKS ON CAMERA	"You knew she would have kicked everyone's butt."	*Viewers tend to click away from unrelentingly sad stories, so I inserted a chuckle to keep them wanting to hear more.*
BACK TO GIRLS' PHOTOS	BRITTHANY [*sic*] "She was friendly. She had a good sense of humor. She loved to smile." NATALIE "She has pretty eyes. She would always carry her Bible to school."	
WIDE SHOT OF BOB DOTSON WALKING ON BASKETBALL COURT, TALKING DIRECTLY TO THE CAMERA.	[STAND UP COPY] Their friends thought you might like to see where . . .	*I chose this location for my on-camera appearance to explain why we did the interview in the gym.*
CUT TO CLOSE-UP OF DOTSON	Paige Herring perfected her jump shot. And Natalie Brooks practiced her cheers. Stephanie Johnson sang her first sweet song right here. And Britthany Varner gave her a hug. She always had hugs for her friends.	*When a reporter faces the lens and speaks to the audience, this is called a stand-up [STU].*
GIRL LOOKS UP FROM YEARBOOK:	NAT SOUND: "It's really sad now that she's not here."	

DISSOLVE TO LOCKER	NAT SOUND: "She had a locker under mine."
PHOTO OF BRITTHANY	**[NARRATION]** **One she could reach. Britthany was only four feet tall.**
PHOTO OF PAIGE IN BASKETBALL UNIFORM	Paige could jump higher than that.
CLASSMATE COLBY BROOKS	"She had good form."
BOB DOTSON	"She could fake you out?"
COLBY BROOKS NODS HEAD	"Uh-huh."
BOB DOTSON	"You admit that?"
COLBY BROOKS	"Uh-huh."
BOB DOTSON	"Wow!"
GIRL SHOWS PHOTO TO DOTSON.	"She gave me a picture of her. One of the pictures that she had."
PHOTO OF NATALIE AND HOLLY	**[NARRATION]** **Holly Montgomery and Natalie Brooks vowed to be best friends forever.**
HOLLY TELLS DOTSON	"She gave me a makeup bag."

PHOTO OF BIRTHDAY PARTY	**[NARRATION]** **For her birthday, the** **same day Natalie died.**
TWO BOYS SHYLY TALKING ABOUT HAVING A CRUSH ON NATALIE	
MICHAEL	"She had the most beautiful eyes. I kinda had a crush on her."
GIRLS EGG HIM ON	"Ooooh!"
COLBY	"Almost everybody in school did."
BOB DOTSON	"Wait a minute. The two of you both had a crush on Natalie."
GIRLS SHOUT	"Colby admitted it. Now admit it!"
COLBY	"Yeah."
GIRLS SQUEAL WITH DELIGHT	"Ooooh!"
HOLLY	"Michael."
MICHAEL	"What?"
HOLLY	"Come on, admit it!"
MICHAEL (EXASPERATED)	"Okay!"

That simple observation, not a question, got every boy to admit he had a crush on the dead girl.
It was a bittersweet moment that showed how close these children were to one another.

KIDS PERCHED ON GYMNASIUM STANDS DOUBLE OVER IN LAUGHTER.	NAT SOUND: GIGGLES AND CHEERS	*The audience has just witnessed a moment of happiness. A fleeting sight of the kind of country America can be. That prompted the "Mount Rushmore grin" line. "Bullets got the best of them" brings us back to the problem.*
	[NARRATION] **These are kids who could make the faces on Mount Rushmore grin.** **But they think bullets got the best of them.**	
GROUP PHOTO OF DEAD GIRLS	HOLLY VOICE OVER "They stayed on the 'A' and 'B' Honor Roll all year."	*Narration over video action is called voice over, or V/O for short.*
INDIVIDUAL PHOTOS	**[NARRATION]** **Stephanie thought she might like to be a nurse. Natalie loved the stars. Britthany always wanted to be Miss America. Paige just wanted a trophy at this month's sports banquet.**	*We went in search of all those images after planning this part of the story.* *You can't write about pictures you don't have. Pre-planning saves time.*
BOB DOTSON	"What are you going to miss the most about these four people?"	
MICHAEL	"Natalie's smile. Personality. Always lending a helping hand."	
HOLLY	"Our school was like a close family, like brothers and sisters."	

CLASSMATES	**[NARRATION]**
LOOKING AT	**Our children are like li-**
YEARBOOK AGAIN	**brary books with a due**
AND THEN FINALLY	**date unknown. These**
CLOSING THE BOOK	**lives stopped at the start**
	of their stories. But their
	stories live on—in friends
	who can tell them.
	For *Today*, Bob Dotson,
	NBC News, Jonesboro,
	Arkansas.

http://www.today.com/video/today/57024266

THE MOST IMPORTANT THING YOU SHOULD DO BEFORE AN INTERVIEW

A young reporter once showed up late to a governor's news conference. Begged the governor to stay and answer just one more question. The Gov, up for reelection, obliged. The reporter focused his camera and said, "Go ahead, governor, answer a question."

"What question?"

"Well, I don't know. Didn't you just have a news conference?"

"Yes."

"Did they ask a lot of questions?"

"Of course."

"Well, pick one out and give me eight seconds!"

And you know—he did.

Most people you interview aren't glib. They're tense, so it's important to help people forget about that camera. Do not talk about the questions you will ask or you may get your best answer before your camera is turned on. While setting up, use the time to help the people you are interviewing become comfortable enough to say what you need to know. Talk about their hobbies, not your equipment. Share a personal story. Be the kind of person in whom people want to confide.

Make the technical stuff seem no big deal. If they're still nervous (and who isn't?), tell a funny story about your own struggles with technology. One of my go-to stories for making an interviewee feel comfortable is about my grandmother, who always worried about my life's work. The first time she got a chance to see one of my stories, I asked her what she thought.

There was a long pause and then she said, "Bobby, I think you ought to learn a trade."

"A trade!"

"Yes, they're not going to keep paying you for two minutes' work!"

That story always generates a chuckle and puts my interviewees at ease, so they're comfortable enough to say what I need to know.

THE BEST THING YOU CAN DO AFTER AN INTERVIEW

How do you pick the best quotes? Robert Frost used to say, "A poem begins with a lump in the throat." Look for sound bites that give you that lump in the throat. They should make you happy or sad, pleased or mad. But they should stick in your memory. When they do, use them. Build your story around that central emotion, not with florid writing, but with strong images. Something you feel compelled to tell. Don't settle for the clichés. Find the compelling emotion.

Great stories are like onions. No, not because they make you cry. They have many layers. They communicate on many levels. They are laced with things that make them widely appealing. On the surface is the tale you must tell, but under that rests a series of strong images and sounds—picture and audio designed to help the viewer *experience* the story, not just learn about it.

HOW TO QUICKLY WRITE A GOOD OPENING LINE

Look at the sound bites you've collected using the Rule of Threes, Filling the Silence and the question that is not a question. Do you have two

good quotes from the same person? You have time to use only one, so paraphrase the information in the second sound bite and make it your lead sentence.

A classmate of those little girls who were killed in Jonesboro showed me a school yearbook and said, "This will tell you about our lives." I decided not to use her quote, but it did give me an idea for an opening line.

"Sometimes the yearbook of life closes too soon."

We had video of students looking through the yearbook, so the line not only matched what we were showing, but it also set the story's emotional tone. When you paraphrase the second-best quote, you give your audience information that is central to your story and a compelling reason to stay tuned.

CHAPTER 2

THE GAME OF WHAT IF?

HERE'S a little mind game to help you work faster and more efficiently. As your story progresses, ask yourself, "If I had to leave right now, what would be my opening shot? My closing shot? What would be the point of my story?" During breaking news, those answers may change minute by minute and, of course, your story must change with them. That's the business you're in. You must make adjustments. But if you keep the end of your story clearly in sight, you can also construct a path that will take your audience there. You won't waste time shooting pictures or interviews you won't need.

HEY. YOU. SEE. SO.

The best stories follow a simple outline:

- **HEY:** (WHACK!) Get their attention. Murder mysteries, for example, begin with a dead body.
- **YOU:** This story may be about a train derailment in India, but this is how it connects to you.
- **SEE:** Here are the details I've found no one else has or if you've heard them before, I'm going to tell them so engagingly, you'll want to hear them again.
- **SO:** This is why you should care.

17

When I'm dealing with a complicated story, filled with many choices, I ask myself, "Where's my HEY? How can I connect my viewers to the YOU? Has SEE covered the important points? SO why is this story important to my viewers' lives?" "HEY, YOU, SEE, SO."

SCRIPT #2: POPS DREAM

See how HEY, YOU, SEE, SO plays out in this script:

ANCHOR INTRODUCTION:
On this morning's *American Story*, Bob Dotson catches up with a man we first met here on *Today* a decade ago. Braeden Kershner had a moment of fame, but stepped out of the spotlight to do something he felt was much more important.

SIXTH-GRADE BAND TEACHER BRAEDEN KERSHNER ENCOURAGES, NOT MUSIC, BUT A SCREAM FROM HIS UNRULY CLASS. HE MAKES A WILDLY FUNNY FACE, REACTING TO THEIR SCREAMS.

BRAEDEN KERSHNER: NAT SOUND:
 "Everybody scream!"

STUDENTS: NAT SOUND: *Here's the HEY. Get the*
 "EEEEEEK!" *viewer's attention.*

AS KIDS SCREAM, CUT TO
THE BAND DIRECTOR'S
HAND, HELD HIGH,
FINGERS COUNT DOWN
THREE, TWO, ONE . . .
CLOSE-UP TEACHER'S
SHOE STOMPS ON
PODIUM

[NARRATION]
Braeden Kershner is
about to show these kids
the small print in big
dreams.

KIDS JUMP.

NAT SOUND: STOMP

TEACHER QUIETS
STUDENTS.

NAT SOUND:
"Here we go!"

KIDS SETTLE IN TO LEARN.

[NARRATION]
A decade ago, when
Braeden was not much
older than they are . . .
he had a flash of fame.

Here's the "YOU." By
showing viewers an
everyday school scene,
it links this story to the
viewer's experience, even
though the story is about a
very unusual individual.

DISSOLVE TO FIRST POPS
DREAM STORY: KEITH
LOCKHART INTRODUCES
BRAEDEN, WHO STEPS
UP TO THE BOSTON POPS
PODIUM, TAKES OFF HIS
COAT AND BEGINS TO
CONDUCT.

Here's the "SEE." A few
major story points.

NAT SOUND: KEITH
LOCKHART
"Please welcome in his
Boston Pops conducting
debut, Braeden Kershner!"

[NARRATION]
The 18-year-old from
Goose Creek, South
Carolina, prepared for
this moment . . .

DISSOLVE TO TEENAGE **. . . by learning to play**
BRAEDEN LEARNING TO **EVERY instrument in the**
PLAY INSTRUMENTS. **orchestra.**
 BRAEDEN KERSHNER VOICE
 OVER
 "If I gave you orders
 and I hadn't played that
 instrument . . .

BRAEDEN KERSHNER [ON CAMERA]
 ". . . you wouldn't take that
 order as seriously."

PAN FROM MIRROR TO **[NARRATION]**
BRAEDEN SITTING AT OLD, **The boy with a dream**
BOXY COMPUTER **had seen an ad on the**
 Internet, saying fans *"Panning" is moving the*
 could conduct the *camera lens.*
 Boston Pops if they
 donated big bucks to
 the orchestra.

BRAEDEN KERSHNER	"It's just money! If that can buy you the thing you wanted all your life, then it's worth it to me."
BRAEDEN TEACHING PIANO	NAT SOUND: PIANO **[NARRATION]** **. . . Braeden worked** **11 jobs.** NAT SOUND: BRAEDEN KERSHNER SHOWING STUDENT "No! (COUNTING MUSICAL BEATS) One, two, three. One . . ."
CONDUCTING	NAT SOUND: OPENING STANZA **[NARRATION]** **Standing on that stage,** **he tallied up what his** **dream had cost.**

BRAEDEN KERSHNER

VOICE OVER
"All the hundreds of yards
I mowed, the hundreds of
cars I washed, all the late-
night jobs."
NAT SOUND MUSIC: STARS
AND STRIPES FOREVER
[NARRATION]
Was the bill a bargain?

BRAEDEN KERSHNER

VOICE OVER
"I could buy a new car, but
it would rust and break
down in 20 years. This is
something I always will
have with me."
NAT SOUND: STARS AND
STRIPES FOREVER

AMERICAN FLAG DROPS
DOWN AND BRAEDEN
KERSHNER'S MOMENT
IN THE SPOTLIGHT
DISSOLVES TO HIS
MARINE PHOTO.

[NARRATION]
That night could have
made Braeden Kershner
a star. Instead, he joined
the Marines, just before
9-11.

BRAEDEN KERSHNER:

VOICE OVER
"The idea was never to be
famous from that. It was
just to accomplish the
dream."

DISSOLVE TO DRUM LINE
MARCHING INTO THE
STADIUM

[NARRATION]
And then . . . guide others
to theirs.

BRAEDEN'S WIFE, JULIE, COMES UP TO BRAEDEN, WHO IS WATCHING THE STUDENTS. SHE LEANS IN, GIVES HIM A HUG AND KISSES HIM.	NAT SOUND BRAEDEN: "Don't they look good?" NAT SOUND JULIE: "Un huh."	
DRUM LINE MARCHES INTO STADIUM	**[NARRATION] Braeden took a job teaching band at Stall High School, just down the road from his boyhood home.**	
HUGGING STUDENTS AT BUS	NAT SOUND: (HUGS) **[NARRATION] Spent five weeks that first summer getting a commercial driver's license so he could bring players to practice.**	
TWO SHOT—BRAEDEN AND FEMALE FORMER STUDENT:	NAT SOUND GIRL: "He's my favoritest teacher!"	*In a "two-shot," two people are framed in the camera's viewfinder.*
BRAEDEN KERSHNER:	VOICE OVER "They didn't know this . . .	
[ON CAMERA]	". . . but it was never about the music. It was about keeping them involved in something positive."	

HALF-TIME SHOW	NAT SOUND BRAEDEN ANNOUNCING: "Half time is show time!"
VIDEO OF ANTON ROSE AND DRUM LINERS PERFORMING AT HALF TIME	NAT SOUND: DRUMMING **STAND-UP VOICE OVER COPY** **Some of the kids on the drum line were on the verge of dropping out of school . . .**
CUT TO DOTSON ON CAMERA OUTSIDE THE STADIUM WITH THE FOOTBALL FIELD AND LIGHTS FRAMED BEHIND HIM.	NAT SOUND: DRUMMING CONTINUES, SOUND UNDER **. . . before Braeden showed how playing that kind of music could make them cool. The Marine sergeant turned their band practice into a happy Boot Camp. They learned teamwork, carrying his couch above their heads. And on rainy days, they put down their instruments and marched in the mud.**
ANTONE ROSE POUNDING DRUM, PERFORMING AT HALF TIME	**[NARRATION]** **Antone Rose now believes anything can be accomplished with practice.**
DRUM LINE DANCING THROUGH GAUNTLET	**Here, failure is forgiven.**

ANTONE DRENCHED WITH SWEAT	**Giving up is not.**
BOB DOTSON:	"How did he change your life?"
ANTONE ROSE:	"He took the word 'can't' outta our vocabulary."
BAND MAJORS PASS BY BRAEDEN, WHO GIVES A DEEP-THROATED ROAR OF ADMIRATION.	NAT SOUND BRAEDEN: "Yeeeeeeah!"
EXTREME CLOSE-UP OF BRAEDEN. YOU CAN SEE HOW PROUD HE IS OF THEM .	**[NARRATION]** **Braeden Kershner taught them how to craft a note and then their lives.** NAT SOUND: "Yeaaaaah! Woooooh!"
BOB DOTSON:	"What's the secret of making big dreams come true?"
BRAEDEN KERSHNER:	"Persistence.
BRAEDEN CONTINUES VOICE OVER VIDEO OF TALENTED BAND MAJORS, DAZZLING WITH THEIR DANCE.	". . . The world is full of a lot of talented people. But the ones that seem to be the most successful try after they fail."
BRAEDEN SLAPS THE BACK OF THE LAST DRUMMER WHO MARCHES BY.	NAT SOUND BRAEDEN: "Awesome!"

BRAEDEN KERSHNER PADDLING A KAYAK THROUGH SALT MARSHES AT DAWN, LAYERED WITH SHOT OF HIS WIFE MODELING BABY CLOTHES ON HER VERY PREGNANT STOMACH

[NARRATION]
They are also the ones who do the unexpected. The man from Goose Creek is about to become a father, but has another dream to finish first.

SET UP A BIT OF MYSTERY WITH A SERIES OF CLOSE-UPS, FINALLY REVEALING THAT BRAEDEN IS PUTTING HIS ENTIRE BODY THROUGH A REGULATION TENNIS RACKET

BRAEDEN KERSHNER:

"I went on a diet of oranges and popcorn for three weeks . . ."

[NARRATION]
. . . preparing for a shot at the Guinness Book of World Records: Putting his body through an ordinary tennis racket 22 times in one minute.

BOB AND JULIE IN LIVING ROOM WATCHING BRAEDEN PRACTICE IN FRONT YARD	NAT SOUND: DOTSON LAUGHING "This is the guy you married, right?" NAT SOUND: JULIE (SIGHS) "Yeah." NAT SOUND: DOTSON LAUGHS **[NARRATION]** **We laugh . . .**
HALF DISSOLVE TO BRAEDEN HOLDING GUINNESS WORLD RECORD PLAQUE WHILE HE REPEATEDLY CONTINUES TO SLIDE THROUGH THE RACKET	**He won.**
THE TEENAGE BRAEDEN CONDUCTING THE LAST STANZA OF STARS AND STRIPES FOREVER AT HIS DEBUT WITH THE BOSTON POPS. FLOAT IN CLOSE-UP SHOTS OF BRAEDEN PLAYING LOTS OF DIFFERENT INSTRUMENTS.	NAT SOUND: MUSIC **[NARRATION]** **Big ideas often begin in small places.**

Here's the "SO." So why should your viewer care?

END ON HIS BOYHOOD FACE, AS HE'S BATHED IN WILD APPLAUSE	**For *Today*, Bob Dotson, NBC News, with an *American Story* in Charleston, South Carolina.**

http://www.today.com/video/today/57024929

The best stories don't just show or tell, they let the audience experience the unexpected. When structuring this story, I asked myself:

- How can we help the viewer experience the "fun boot camp?" or the nervousness of a "loner band geek" and the joy of that geek becoming a hero in other kids' eyes?
- What blueprint can we show that explains how Braeden kept Antone in school, when Antone and half the kids in the drumline were on the verge of dropping out of school?

We know what Braeden wants to accomplish with his new batch of band students. We've all seen that movie many times. The trick to telling an inspirational story is never to be inspirational (read: predictable).

SURPRISES

Build into every story a little surprise—an abrupt natural sound, unanticipated video or unsuspected turn in the script. Anything to rivet a viewer's attention. For instance, how does a guy top conducting the Boston Pops on national TV? He goes for a Guinness World Record, jumping through a tennis racket. (SURPRISE!) Braeden could have gone to any college

in the country after the *Today Show* piece aired. The Pops returned his money and he was offered full scholarships to some big-name schools. Instead, he joined the Marines. (SURPRISE!) He could have become a symphony conductor; instead he took a band director's job teaching music to Antone in a "fun" high school boot camp. (SURPRISE!) All that will leave the audience wondering what kind of guy keeps scaling down his horizon and yet continues to dream big and succeed. They'll stick with us throughout the spot for the answer. Surprises lure uninterested viewers to the screen, help them feel something about the story.

SCRIPT #3: FARM TO FAME

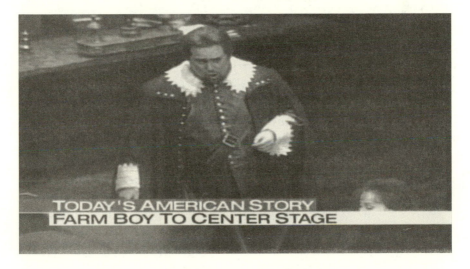

Let's look at the surprise turns in this story:

ANCHOR INTRODUCTION: TODAY'S *AMERICAN STORY WITH BOB DOTSON BEGINS* IN CENTENNIAL, COLORADO, BUT *ENDS* WHERE YOU WON'T BELIEVE. THIS ONE IS FOR ALL OF US WHO SING IN THE SHOWER AND DREAM.

BIG SKY WIDE SHOT— FRONT LOADER PICKING UP DIRT IN SILHOUETTE	NAT SOUND: COUNTRY SONG ON RADIO, MIXED WITH TRACTOR SOUND

[NARRATION]
In most of the country, time is cut in tiny slices, too thin for thought. But out here on the high plains, the rhythm of life is different.

I opened the piece, not at the Metropolitan Opera, as the press release suggested, but on a farm. It's always best to begin at the beginning. See where the story started.

NAT SOUND: COUNTRY SONG ON RADIO, SOUND UP
"(SINGING) He's on the dance floor yelling, Free Bird . . ."

WE SEE CHUCK TAYLOR CLOSE-UP THROUGH THE FRONT LOADER'S WINDOW. LOADER LIFTS DIRT AND COVERS HIS FACE.	**[NARRATION]** **From dawn to dusk, Chuck Taylor would listen to the radio and wonder why *he* wasn't making music.**

CHUCK SINGING ALONG WITH COUNTRY SONG PLAYING ON RADIO	"(SINGING) . . . singing off key, but he knows every word!"	*Chuck represents all of us who dream. I made this point here to hook a wider audience.*
CHUCK TAYLOR SITTING IN FRONT LOADER	VOICE OVER—HAWK SOARING "Look around you. There is beauty and music everywhere . . ."	
ON CAMERA	" . . . I just wanted to do my part. I wanted to express what I was feeling."	
PRETTY GIRLS WALKING ALONG CAMPUS	**[NARRATION] He also thought it might be a good way to meet girls.**	
CHUCK TAYLOR LAUGHS.	"I wanted to be a rock star, but Meatloaf already kind of conquered the 'chubby, long-haired guy thing' back in the '70s."	*Humor is a great way to engage an audience. If they like Chuck, they will stick around to see his story.*
PAN—CLOSE-UP OF SHEET MUSIC	**[NARRATION] So, one day, the farm hand from Centennial, Colorado, auditioned for something else.**	
HAND STRIKES CHORD IN COLORADO REHEARSAL HALL.	NAT SOUND: MUSIC (PIANO CHORD)	*Here's the first turn in the story. Chuck is not heading to a Country Western bar.*

CHUCK SINGING WITH COLLEGE PROFESSOR	"(SINGING) Reeeespooooond. (HOLDS NOTE)

[NARRATION]
Elizabeth Elliott, the opera director in Fort Collins, was stunned.

ELIZABETH ELLIOTT OPERA FORT COLLINS	"Brought tears to my eyes. It's not often that somebody comes in and sings something that just makes your spine straighten and it wasn't just the voice. Chuck has soul."	*I picked this quote (sound bite) because Ms. Elliott describes Chuck's talent articulately and in terms we all understand.*

TAYLOR TOSSES ANOTHER SINGER TO THE FRONT OF THE STAGE, THEN APPROACHES MENACINGLY.	NAT SOUND: SINGING "May I suggest you think it over?"

[NARRATION]
Just 18 months after this first role in Colorado . . .

SLOWLY DISSOLVE TO BEAUTIFUL EXTERIOR NEW YORK CITY METROPOLITAN OPERA	**. . . he won a national audition to sing *full-time* . . .**

DISSOLVE TO ZOOM OUT FROM STAR FILTER CANDLES. CHUCK WALKING TOWARD CAMERA	**. . . at the Metropolitan Opera in New York City.** NAT SOUND: CHUCK BEGINS TO SING **[NARRATION]** **The only Italian he knew was double latte.**

QUICK DISSOLVE TO MUSICAL RIM SHOT IN MAKEUP ROOM: SEE CHUCK'S REFLECTION IN MIRROR, TILT UP FROM CHUCK SINGING LIKE A BLUES GUITAR TO THE MAKEUP GUY	NAT SOUND: CHUCK SINGING BLUES GUITAR CHORDS	*A TILT UP is when the camera moves up.*
CHUCK TAYLOR VOICE OVER: MAKEUP GUY WORKING ON CHUCK	"I'm a college drop-out. I was a high school drop-out before that."	*Note that the story takes another turn, revealing how far this country guy has come in life. Don't just*
CHUCK TAYLOR VOICE OVER	"I can barely read them little notes on the page."	*state a headline and spend the rest of your story time explaining that headline. No matter how short, your tale should unfold in a series of surprises that build to a close.*
CHUCK TAYLOR ON CAMERA LAUGHS.	NAT SOUND: LAUGHTER	*I put in a brief natural sound pause to allow time for the viewer to react. Chuck's ability to make us laugh underscores his likability.*

BOB DOTSON SPUTTERS IN DISBELIEF.	"You're a Metropolitan Opera singer and you can't. . . . How do you do it?"	
CHUCK TAYLOR	"I hire somebody or have a good enough friend that plays piano . . .	
TAYLOR LISTENING TO MUSIC ON DISC PLAYER	". . . to plunk down the notes on a mini-disc recorder for me."	
CHUCK HOLDING PAPER AND SINGING WITH AN EVIL EYE AS HE STALKS TOWARD CAMERA, SNAPS PAPER IN FRONT OF LUCIA, WHO IS REVEALED AT END. CAMERA FOLLOWS HER AS CHUCK MOVES OUT OF FRAME.	NAT SOUND: CHUCK SINGING OPERA	
	[NARRATION] **Talent got him here. Hard work put him center stage.**	*Given Chuck's lack of formal training, it is important to tell the viewer at this point how he got to the big time.*
CUT TO CONDUCTOR AND ORCHESTRA, THEN DISSOLVE TO SIGN OUTSIDE MET, TILT DOWN TO CHARLES TAYLOR'S NAME	[NARRATION] **This month—six years after leaving the farm— Chuck, now *Charles* Taylor, has a leading role . . .**	*The Metropolitan Opera press release suggested we lead with this headline, but it's much more impressive after you know his back story.*

CHUCK LEADS LINE OF OPERA STARS OUT FROM BEHIND CURTAIN, TAKES OFF HIS HAT AND BOWS.	NAT SOUND: APPLAUSE UNDER **. . . in the largest opera house in the world.** NAT SOUND: APPLAUSE UP	
CHUCK TAYLOR	VOICE OVER "I still fight with the feeling of being a fraud." **[NARRATION]** **But he has lived the kind of life they write about in operas.**	
CHUCK TAYLOR ON CAMERA	"I should be dead. Or at the very least, probably in jail or in a box somewhere—begging change. And here I am living this dream."	*The story doesn't dwell on the headline. It immediately takes a turn to reveal an even bigger challenge to Chuck's success.*
CLOSE-UP OF SHEET MUSIC. DISSOLVE TO THE CAMERA LENS MOVING UP FROM WIDER SHOT OF SHEET MUSIC TO FIND DOTSON WALKING AROUND PIANO.	**STAND-UP COPY, STARTS AS VOICE OVER** **Taylor loved hitting high notes, but loved *getting* high better. He was kicked out of school for drinking. Started taking drugs and living in a van. At 24, after the deaths of several friends, he hit bottom.**	*I told on-camera an important story point that I could not show with video or get from Chuck during his interview. It's put here to reveal how far he had to come.*

CHUCK TAYLOR	"I really thought I was helpless and hopeless."
CHUCK TAYLOR TEACHING MASTER CLASS AT COLORADO STATE UNIVERSITY	**[NARRATION] Until music became his lifeline.**
CHUCK TAYLOR TALKING TO STUDENT ABOUT TO SING ON STAGE	NAT SOUND: CHUCK "So you are trying to woo this chick. All right? So woo me! (STUDENT LAUGHS)."
SLOWLY DISSOLVE FROM LAUGHTER TO SUN BURST, TILT DOWN TO COLORADO STATE UNIVERSITY SIGN	**[NARRATION] Chuck is also teaching at Colorado State University, the school from which he did *not* graduate.**
STUDENT TRIES TO SING AS INSTRUCTED.	NAT SOUND: STUDENT SINGING "Ahhh la King!"
CHUCK CONGRATULATES STUDENT.	NAT SOUND: CHUCK "Better."
BOB DOTSON	"You're one big Cinderella to them."
CHUCK TAYLOR	"You should see me in a tutu!"

Chuck's common touch relates to the students. That's why I put this exchange here. Another fun moment to keep the audience hooked to the story.

FELLOW OPERA SINGER EDUARDO VALDES IS KIDDING AROUND BACK STAGE WITH CHUCK.	NAT SOUND: EDUARDO "Do you know Ricky Martin?"
CHUCK	"Si!"
	[NARRATION] He's learned to have fun without drugs.
EDUARDO	NAT SOUND: "How about 'La Vida Loca?'"
	NAT SOUND: CHUCK SINGS "Up side. Inside out . . ."
CRACKS UP EDUARDO	**[NARRATION] Not serious, but sober—11 years.**
	NAT SOUND: LAUGHTER
CHUCK WITH WIFE KELLY	**[NARRATION] Chuck even found that girl he went looking for when he left the farm . . .**
CHUCK AND KELLY'S WEDDING PHOTO	**. . . and managed a storybook ending.**
KELLY TAYLOR, CHUCK'S WIFE	"Chuck is the kind of guy people want to be around."

You must answer all the questions that you have raised in your script. Did he find the girl he went looking for?

	[NARRATION] **Just to see what will** **happen next.**
BOB DOTSON WALKING ALONG RIVER WITH CHUCK TAYLOR	"So what are you going to do when the fat lady sings on your opera career?"
CHUCK TAYLOR	"I'm going to get back home. Back out here."
RIVER SCENIC	**[NARRATION]** **Where the rivers twist** **and turn, a mirror** **of his life . . .**
CLOSE-UP OF CHUCK SINGING AT OPERA WEDDING SCENE; PUTS ON HIS HAT AND BEGINS TO SING	NAT SOUND: OPERA ENSEMBLE SINGING IN BACKGROUND **. . . the one that could** **have ended tragically,** **like the operas he sings.** NAT SOUND: CHUCK SINGS **For _Today_, Bob Dotson,** **NBC News, with an** **_American Story_ in New** **York City.** NAT SOUND: SOUND UP FOR PHRASE, THEN OUT)

Stuck for a closing line? Ask yourself, "What does this story mean?" "Why is this story important to the viewer?" What prompted my closing line? The creek bed we were walking in wound all over the pasture, just like Chuck's life.

http://www.today.com/video/today/57024322

Did you spot the surprise? It was carefully placed after the HEY and the YOU in our story structure. First we hear a beautiful voice coming from a farm

field (the HEY). It gets your attention. Then we are shown its source—an ordinary guy who looks a lot like us (the YOU). The SEE what I've learned contains the surprise. Chuck says, "I should be dead or at the very least, probably in jail or in a box somewhere, begging for change." During his interview, I pointed out that he had started his singing career later in life. (That exchange is not in the script. I was simply posing a question that is not a question.) His response revealed a much deeper story.

HUMOR

Relatively few people follow opera, so I showcased Chuck's good humor to make viewers want to know his story. Nothing transforms human apathy quicker than a laugh. If someone is naturally funny, allow time in your story for that humor to hook the audience.

STRUCTURING A VISUAL STORY

Crafting an effective HEY, YOU, SEE, SO story involves more than interesting plot twists. Look at the following outline I jotted down after a quick phone conversation with Kyle Lindsey, a young man who had become a YouTube star. It lists not only the points I wanted to make in my profile of Kyle, but also the pictures we'd need to prove those points. First I tried to answer the "So What?" test. How does a seemingly ordinary person become an Internet star? Then I searched for the surprises in the information I had gathered in my phone interview. Those would become the twists and turns in my tale. I stacked the surprises so they would build to an ending. After that, I "wrote" my pictures, making sure the video would flow logically from start to finish. (For example, you wouldn't show a child going to school and then waking up.)

PLANNING NOTES FOR
YOUTUBE STAR SEGMENT

Here's the outline I created on the way to the assignment:

We open with the five-year-old Livonia, Michigan, boy Andrew Kees playing around in his family's car.

Note that I did not start with the YouTube star. We begin with one of the viewers who made him so popular.

Talk about the little boy's love of automobiles.

Show family pix taken during the time of his brain tumor operation.

Say—he's recovering from brain surgery.

Show him clicking on one of Kyle Lindsey's YouTube car videos.

Why didn't I start with the subject of our story, the YouTube star? I needed to establish why so many people watch his videos.
The little boy acts as mirror reflecting the star's appeal.

SURPRISE STORY TWIST #1: Say—the boy's greatest comfort is the sound of an ordinary voice telling him about ordinary cars.

GRAPHIC: Fill the screen with dozens of reviews.

Every story, no matter how short, should be a series of surprises. Look over your notes for all the twists and turns that will keep a viewer's interest.

SURPRISE STORY TWIST #2: Say— Andrew is not alone in his attraction. In the past three years that voice has gone viral, pulling in more than 101 million views on YouTube.

Show some fast-talking, over-the-top huckster from the Speed Channel. Compare with Kyle's not-so-slick voice over review.

Stand-up—Dotson in car lot: The person behind that voice is not who you would expect. He sells neither cars nor himself. In fact, he's seldom even seen on camera. That's because he's busy with his day job.

Your on-camera copy should also build to a surprise. This story twist introduces the YouTube star, giving viewers information they cannot see for themselves.

Show Kyle working at the Harris Teeter Grocery store pharmacy in Greensboro, NC.

SURPRISE STORY TWIST #3: Say—the 22-year-old works in a grocery store, studying full-time for his doctorate in pharmacy.

Kyle is an ordinary guy. Just like his audience.
This point is made here to hook the viewer.

Show Kyle taping video at car lot, chose a car that to most might be an old clunker.

Say—his hobby started when Lindsey got bored one day and decided to make some "random videos." Like a lot of hobbies, it kind of got out of hand. This is his 1,476th. They are no-nonsense, sales free, test drives of cars new and OLD, like the ones most of us end up buying. No matter how old or ordinary, every car is treated to the same 10-to-20-minute walk around and test drive.

We all sometimes binge on our hobbies. Another point to help viewers relate to the YouTube star.

"Basically," Lindsey says, "I like to think about myself as the purest automotive enthusiast you can find. With zero bias. There's always something about a car where I'm like, 'Oh, that's pretty neat!' "

Show—Kyle editing and uploading video review. Show the house he lives in.

SURPRISE STORY TWIST #4: Say—Kyle accepts no money from dealers, but his part-time hobby now covers the rent on his house, all of his college bills and living expenses.

Show montage of his YouTube videos and figures. Ending with shiny Dodge Charger.

SURPRISE STORY TWIST #5: Say—folks at Google noticed that Kyle's clips were getting millions of clicks from all over the world. They added commercials. Paid him 30 cents the first month. $5,000 the next. Now his part-time hobby earns him six figures, enough to buy three cars.

I make a story turn to show how much Kyle's hobby changed his life and placed this story twist here to foreshadow the big decision Kyle faces.

Show Kyle cleaning cars, then driving off, not in the muscle car or the vintage Ford, but "your dad's" Buick.

SURPRISE STORY TWIST #6: Say—What does a man who's seen everything prefer to drive? Not the 2012 Dodge Charger or the cherry condition 1965 Ford Fairlane. This 1995 Buick Riviera. After all, a guy who balances a full college-course load, a part-time job, a breakneck video-production pace, and a girlfriend doesn't need a sports car. He needs a place to relax.

Show Kyle working at the pharmacy again, then Andrew Kees back in Michigan.

SURPRISE STORY TWIST #7: Say—Kyle's part-time hobby already pays him more than most pharmacists. But he's still planning on a life in medicine, after graduating next spring. He wants to help kids like that little boy in Michigan, the one who came to see him after recovering from brain surgery.

I set up Kyle's hard choice. He loves pharmacy but his hobby makes him more money.

Show—the video of the two meeting.

I bring the story back to where we started. One of Kyle's biggest fans helps him decide. This resolution should come at the end of the story.

Andrew Kees wanted to meet the car man whose enthusiasm and deep knowledge filled his brain with more than a tumor.

More than a shared love of cars
connects them. They were pulled
together by the passion of an ordinary
voice.

TAG: Andrew is now cancer free.

I held off revealing Andrew's condition until after I'd ended Kyle's story. Don't fuzzy up a story's focus by switching back and forth. Remember Andrew's story is here to hold a mirror up to Kyle's accomplishments.

WHAT WENT ON THE CUTTING ROOM FLOOR

Even with a carefully constructed story plan, some things won't work out and unexpected moments will be better. That's why you will often shoot much more video than you can use. It's not unusual to record four times as much or more, as the story changes. How do you pick what ends up in your script? Go back to HEY, YOU, SEE, SO. That will help you find the best video. Pretend these pictures are building blocks and see what fits together. They will begin to flow logically from one to the next, from the beginning to the middle to the end. If you can turn down the sound and still understand the story progression, you've picked the right visuals. The rest you leave out.

Let's see how much of the original outline for our YouTube star story ended up in the finished script:

SCRIPT #4: YOUTUBE STAR

ANCHOR INTRODUCTION:
TODAY'S *AMERICAN STORY
WITH BOB DOTSON* COMES
FROM REIDSVILLE, NORTH
CAROLINA, HOME TO ONE OF
THE MOST POPULAR PEOPLE
ON THE INTERNET—NOT AN
ENTERTAINER OR SPORTS
STAR—JUST AN ORDINARY GUY.
BOB IS HERE TO TELL US ABOUT
HIM.

DOTSON IN-STUDIO:
GOOD MORNING. HE MAY *SEEM*
ORDINARY, BUT YOU HAVE TO
LOOK CLOSELY TO SEE HOW
SPECIAL KYLE LINDSEY CAN
BE. I LEARNED THAT FROM HIS
LITTLEST FAN.

OPEN ON 6-YEAR
OLD ANDREW KEES
CAREENING AROUND
HIS BACKYARD IN A TOY
CAR.

NAT SOUND: TOY CAR RATTLING
PAST CAMERA
[NARRATION]
**6-year-old Andrew Kees has a
love affair with cars. It began
. . .**

DISSOLVE TO FAMILY
PHOTO, ANDREW'S
HEAD WRAPPED IN
BANDAGES AFTER HIS
OPERATION.

**. . . when he was diagnosed
with a rare brain tumor.**

KYLE LINDSEY VOICE OVER:
"Ready for a little ride?"

*We could have used
more video of Andrew
playing, but decided to
show a picture of him
recovering from his
brain operation.*

ANDREW SITTING ON HIS BED, LOOKING AT ONE OF KYLE LINDSEY'S CAR REVIEWS ON AN IPAD. THE ON-SCREEN CAR DRIVES OFF.	**[NARRATION]** **His greatest comfort was the sound of this voice.** NAT SOUND KYLE [V/O]: "Hey everybody, how's it going?"	
GRAPHIC: FILL THE SCREEN WITH DOZENS OF REVIEWS.	**[NARRATION]** **Andrew wasn't the only one listening. In the past three years those reviews have been seen more than 100 million times on YouTube.**	*I held off showing Kyle to create a bit of mystery. Who is behind the voice that so intrigues a sick child?*
DOTSON STAND-UP— UPLOADED INTO ANDREW'S YOUTUBE WEBSITE. HE'S WALKING THROUGH A CAR LOT AND APPEARS TO BE PART OF ANDREW'S YOUTUBE PRESENTATION.	**STAND-UP COPY** **"The person behind that voice is not who you would expect. He sells neither cars, nor himself. In fact, he seldom appears on camera. That's because he's busy with his day job."**	
KYLE, THE SCIENTIST, FILLING A SYRINGE WITH MEDICINE INSIDE AN ISOLATION CHAMBER. DOTSON DRIVES UP IN 1965 FORD FAIRLANE AND CALLS TO KYLE.	**[NARRATION]** **The 23-year-old is a scientist, studying *full-time* for his doctorate in pharmacy.**	*We had footage of Kyle working in a pharmacy. That ended up on the cutting room floor. It wasn't as interesting as video shot in a drug isolation chamber. I wrote to the video by using the word "scientist" in my line of narration.*

BOB:	"How are you?"
WE CAN SEE KYLE THROUGH THE CAR WINDOW.	
KYLE:	"Good. How are you?"
HIGH ANGLE SHOT OF TWO CARS	**[NARRATION]** **Kyle started his car reviews to relieve the stress of college.**
BOB DOTSON, TALKING TO KYLE, CAR TO CAR	"Did you just stumble into this?"
KYLE LINDSEY	"Yes, sorta, (LAUGH) actually."
KYLE STEPS INSIDE ANOTHER CAR, HOLDING A CAMERA, AND BEGINS TAPING ONE OF HIS REVIEWS.	**[NARRATION]** **During a break from his studies, he decided to make a random car video.**
	NAT SOUND: "So, I'm just going to start her up and let her run . . ."
KYLE SHOOTING VIDEO	**[NARRATION]** **A bumper-to-bumper tour, demonstrating everything.**
KYLE LINDSEY	"It's almost like a little car encyclopedia in a video format."

We tossed out the idea of doing a standard sit-down interview. Kyle is a car guy. Why not interview him in two of his classic cars?

Kyle rarely appears in his videos, so we shot him making one. We only used a small portion. The rest ended up on the cutting room floor.
Why?
Our video became a springboard into Kyle's many video reviews. It is better to show his work here.
Why?
The viewer is trying to answer the question, "What's the big deal?"

MONTAGE OF KYLE'S YOUTUBE REVIEWS	**[NARRATION]** **His hobby got a bit out of hand.** NAT SOUND: "Good gracious!" **[NARRATION]** **Kyle did nearly one a *day*, about *fifteen hundred*, so far. No nonsense, sales-free examinations of practically anything with wheels and an engine.**
YOUTUBE VIDEO SHOWING CAR SPEWING EXHAUST	NAT SOUND: "Oh Lord!" "Oh don't die."

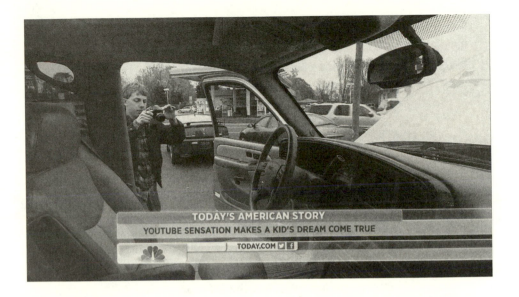

SET UP OF PARENTS TALKING TO DOTSON. THEY ARE SITTING AROUND THEIR DINNER TABLE.	**[NARRATION]** **His mom began to worry.**	*I did not use quotes from Kyle's parents telling us how proud they are of him. That's obvious. The sound bites we did use both challenged and inspired Kyle's hobby. That's important to know at this point.*
JAN LINDSEY	"I thought it was the biggest waste of time."	
BILL LINDSEY LOOKING AT HIS WIFE	**[NARRATION]** **But his dad knows winners aren't always the most obvious.**	
MAJOR LEAGUE BASEBALL VIDEO: BILL LINDSEY PLAYING WITH THE CHICAGO WHITE SOCKS IN THE 1980s	NAT SOUND: BASEBALL ANNOUNCER **[NARRATION]** **Bill Lindsey played eight months with the Chicago White Sox, after nine years of trying.**	

KYLE EDITING ONE OF HIS REVIEWS ON COMPUTER	NAT SOUND: EDITING **[NARRATION]** **That's how Kyle learned the small print in dreams.** BILL LINDSEY [V/O] "When he starts something, he finishes it.	
BILL LINDSEY ON CAMERA FOR PAY OFF	". . . And he's not happy until it's perfect."	
KYLE TWEAKING A SCENE IN EDITING	NAT SOUND: REVVING ENGINE **[NARRATION]** **He accepts no money from the car industry, but the folks at YouTube . . .**	
YOUTUBE ADVERTISEMENT KYLE RECORDING REVIEW. SET UP SHOT, SEEN THROUGH THE DOOR OF HIS BEDROOM/ OFFICE	**. . . started selling ads with his reviews.** NAT SOUND: KYLE RECORDING A NARRATION (UP BRIEFLY) "The Maserati GranTurismo . . ." **[NARRATION]** **Now his part-time hobby pays him six figures . . .**	*The YouTube ads never made it into our spot because we could not show them, so we simply cut to copies of those ads that hung on the walls of Kyle's office.*
HIGH ANGLE SHOT OF THE FOUR CARS	**. . . enough to buy four cars.**	
THREE OF THE FOUR POP OFF THE SCREEN, ONE AT A TIME, LEAVING ONLY THE '48 FORD.	NAT SOUND: POP POP POP **[NARRATION]** **What does a man who's seen everything prefer to drive?**	*The viewer can relate to what Kyle bought with his newfound wealth.*

KYLE LINDSEY	"My real heart and my real passion is for the classics." **[NARRATION] Like the '48 Ford his grandparents filled with love.**	*Now we're not talking cars. We're talking memories like the ones most of us have. I could have used more of Kyle's home movies, but they were left out after I saw Kyle teaching his girlfriend how to drive the same kind of car his grandparents drove. Makes a perfect transition from home movie to new video.*
FAMILY VIDEO— SIX-YEAR-OLD KYLE RIDING WITH HIS GRANDPARENTS, AS THEY DRIVE PAST THE CAMERA IN THEIR '48 FORD	JAN LINDSEY [V/O] "Look at Kyle in there between Momma Dean and Papa!"	
KYLE TEACHING CRYSTAL HOW TO DRIVE A STICK SHIFT	**[NARRATION] He's teaching girlfriend Crystal Willis how to drive one just like it.**	
THE CAR LURCHES AWAY AND STALLS.	NAT SOUND: KYLE TALKING TO CRYSTAL "Give it a little gas. NO! Too much."	
CAR SPEEDS OUT OF FRAME.	**[NARRATION] On their first date, he picked her up . . .**	
DISSOLVE TO PHOTO: KYLE'S HYUNDAI GENESIS	**. . . in a Hyundai.**	
CRYSTAL WILLIS STANDING WITH KYLE AND BOB IN DRIVEWAY	NAT SOUND: CRYSTAL "I guess he can tell you how Hyundai is doing a lot better now." (BIG LAUGH)	*This quote is a wonderful, funny moment. What else from this interview could top this?*

KYLE SORTING PILLS IN PHARMACY	**[NARRATION]** **So is Kyle.** **He's making more than most pharmacists. Does he still plan to wear a white coat and count pills?**	
ANDREW, HIS MOM AND TWIN TODDLER BROTHERS: HE IS TOSSING CARS AS FAST AS HE CAN DOWN THE CHUTE IN HIS TOY GARAGE, THEN TOSSES ONE AT HIS MOM. MATCH CUT TO CLOSE-UP ANDREW'S MOM AS HE TOSSES ANOTHER CAR	NAT SOUND: LAUGHTER AND PLAY **[NARRATION]** **The little boy with the brain tumor helped him decide.** NAT SOUND: MOM LAUGHS	*We did not end up editing this segment as I envisioned in the script. Better to set up Andrew playing with his mother and brothers. Use the tossed car as an exclamation point. A visual sting to close the scene.*
CUT BACK TO ANDREW	**[NARRATION]** **Last summer, Andrew's mom told him:**	
MICHELLE KEES, ANDREW'S MOM KYLE SETTING UP HIS TRIPOD	"You have one wish. What would you want in the whole wide world?" **[NARRATION]** **To watch Kyle tape a review.**	*Notice how the line of narration finishes what Andrew's mom said? You can make a story shorter while using only the strongest part of a quote.*

ANDREW KEES	"I'm never going to because it's going to be too expensive."	*This quote, a little boy's sad reflection, sets up how improbable his dream is. Nothing else in Andrew's interview tops this.*
CLOSE-UP OF ANDREW'S FOOT PUSHING THE GAS PEDAL	NAT SOUND: KYLE "WHOOSH"	
	[NARRATION] **But *this* dream came true.**	
KYLE LEANS OUT OF THE BACKSEAT AND ASKS ANDREW:	NAT SOUND: KYLE "You going on a trip?"	
ANDREW IN DRIVER'S SEAT OF AN OLD VAN, WHILE HIS BROTHERS PEEK IN	**[NARRATION]** **His family traveled 600 miles from their home near Detroit . . .**	*We cut to a shot of Andrew's little brother crawling into a car. That answers the question: "Who are those kids with Kyle?"*
ANDREW STARTS CAR AND HIGH FIVES KYLE.	**. . . so he could meet the man who eased his pain.** MICHELLE KEES, ANDREW'S MOM [V/O] "Andrew's wish was given to him at a time . . .	*This quote from Andrew's mom puts a lump in your throat. That's why we used it here. The rest of her interview? Snip. Snip. Gone.*
MICHELLE KEES ON CAMERA FOR PAYOFF	". . . when we didn't know if he would survive."	

ANDREW SEEN THROUGH OPEN CAR DOOR, SITTING IN DRIVER'S SEAT. STARTS CAR AND TROMPS ON THE GAS.	NAT SOUND: ENGINE STARTS **[NARRATION]** **By year's end he was cancer free.** NAT SOUND—KYLE: "Nice!"
QUICK CUT MONTAGE OF KYLE AND ANDREW SCAMPERING FROM CAR TO CAR, TOTALLY ENJOYING THEMSELVES	**[NARRATION]** **Kyle will continue studying to be a pharmacist. His enthusiasm and deep knowledge . . .**
DISSOLVE TO PHOTO OF LITTLE BOY STANDING IN FRONT OF CAR. SLOW ZOOM INTO HIS SMILE	**. . . have already filled one little boy's prescription for recovery.** **For *TODAY*, Bob Dotson, NBC News, with an *American Story* in Reidsville, North Carolina.**

http://www.today.com/video/today/57024469

CHAPTER 3

GETTING STARTED

LOOK FOR DIFFERENT WAYS
TO TELL YOUR STORY

THE most important part of the story process is the short time you spend at the beginning, deciding how best to visualize what you want to say. You can't structure a visual story if you don't have the right building blocks. Take a few minutes. Imagine that your eye is the camera. What will you need to see to grab the viewer's interest? Now go shoot that.

Use your imagination. Try covering a basketball game from the mascot's point of view with your camera inside the headgear. The best storytelling is filled with details most people don't see. If you go into a kitchen and notice a bushel of green apples covered with dust, don't just shoot a wide shot of the room. Focus on the dusty apples. That image tells the viewers a lot more. Think of it as writing to the corners of the picture. Open your eyes and ears—all your senses.

Look for things the audience cannot see or hear for themselves. Don't waste time pointing out the obvious. Tell viewers what they might have missed even standing next to you. For instance, a huge tornado blows through a pine forest. You notice the smell driving to the story. Later, when scripting, you remember that at the time you were trying to figure out how big the storm was. So, write:

"You could smell the storm's path before you could see it. A forest of torn trees, half a mile wide and 20 miles long."

The following story is an example of writing to the corners of the picture to add meaning and context. Here, it gives the viewer more reasons to care about a man they will never meet.

SCRIPT #5: FOUND ART

ANCHOR INTRODUCTION:
TODAY'S *AMERICAN STORY WITH BOB DOTSON* COMES FROM A FOREST FILLED WITH SURPRISES. IT'S JUST OUTSIDE THE TOWN OF WALDOBORO, MAINE. BOB IS HERE TO TELL US WHAT HE DISCOVERED.

BOB DOTSON IN-STUDIO:
GOOD MORNING. I TRY NEVER TO OVERLOOK THE SMALL THINGS IN LIFE. THEY COULD LEAD TO SOMETHING BIG. SO WHEN A SEVEN-YEAR-OLD GETS EXCITED, I STOP TO SEE WHY.

CAR COMES TOWARD CAMERA FRAMED NICELY BEHIND BUSH. PAN TO HOME AND ZOOM INTO YARD ART.	MUSIC **[NARRATION]** **Think of what you drive by every day . . . and don't see.**	*At first we couldn't find this place. That prompted the idea to start with a car driving by and not stopping.*
SEVEN-YEAR-OLD DOUGLAS GEIS SMILES AND BECKONS TO THE CAMERA. HE TURNS AND CLIMBS ROCK STAIRS.	NAT SOUND: "Follow me!" **[NARRATION]** **Douglas Geis notices more than most.**	

ANNABELLE NICHOLLS RUNS INTO FRAME FROM BEHIND CAMERA AND DOWN INTO GLEN NEAR STREAM.	**[NARRATION]** **He and his cousins have found a five-acre forest filled with wonder.**	*The challenge: How to tell a visual story about a person the viewer will never meet.*
		The solution: His grandchildren playing in the country's coolest backyard. They could lead the viewers on a hunt for their grandfather's art.
BRIEF MONTAGE OF SCULPTURES	MUSIC UP, THEN UNDER	
DOUGLAS GEIS STOPS CLOSE TO CAMERA AND ASKS, THEN RUNS AWAY, NOT WAITING FOR AN ANSWER:	NAT SOUND: "You want to see something cool?"	
FISH SWIM ON CIRCLE SCULPTURE WITH DAPPLED LIGHT. FAIRY FRAMED WITH STREAM IN BACKGROUND. MERMAID RIDING ON YELLOW SUBMARINE	**[NARRATION]** **Yup, that's a mermaid riding a submarine.**	*Sometimes, even when we see things, we don't see details. The storyteller's job is to point them out by writing to the corners of the picture. Instead of talking about what they can see, show them what they might*
FISH SKELETON MADE OUT OF PICKAXES STACKED TOGETHER	**[NARRATION]** **And there's a fish skeleton, made out of pickaxes.**	*overlook.*

ANNABELLE NICHOLLS WALKING WITH BOB DOTSON TOWARD SCULPTURE THAT LOOKS LIKE HELICOPTER. BOB DOTSON:	"Now, what is this?"

ANNABELLE NICHOLLS PLAYS WITH HELICOPTER SCULPTURE. ANNABELLE NICHOLLS:	"It's a time machine."

Foreshadowing the story to come.

GRAPHIC SPIN TO FAMILY PHOTO OF NATE NICHOLLS	**[NARRATION]** **Created by their grandfather, Nate Nicholls,**

DISSOLVE TO HIS WELDED SELF-PORTRAIT	**a farmer who also planted art.**

This man doesn't just turn junk into craft to sell at county fairs. He makes art out of tools that can no longer be used. Farmers wear things out. They don't toss things away. I placed that here to give the viewer a deeper insight into the artist.

CLOSE-UP OF WELDING TORCH SPARKING	NAT SOUND: SPARKING **[NARRATION]** **He would weld together whatever he saw in worn-out tools.**

JOSH NICHOLLS:	"Everybody else looks up in the clouds and says,

DRAGON LOW ANGLE WITH BEAUTIFUL SUN THROUGH AUTUMN LEAVES	'Oh, that cloud looks like a dragon.'"
JOSH NICHOLLS ON CAMERA	"My dad looked down at the ground and said,
JOSH NICHOLLS [V/O] EXTREME CLOSE-UP OF RUSTY MONKEY FACE. ITS EYES ARE GRAY MARBLES THAT LOOK LIKE CATARACTS.	'That wrench looks like a monkey.'"

BOB DOTSON WALKING OUT OF NATE'S WELDING SHED	**STAND-UP COPY** **Nate said these creatures so filled his heart, he felt compelled to give them life. None of them made him much money, so every day for 25 years . . .**	
CUT AWAY TO LOW-ANGLE SHOT OF HUMMINGBIRD SCULPTURE FRAMED IN TREES WITH SUNBURST AND DRAMATIC CLOUDS ABOVE	**. . . he hid another one in his woods.**	*The reporter on-camera stand-up writes to the corner of the pictures, telling why grandpa hid his sculptures. The copy builds to a shocking revelation.*
CUT BACK TO CLOSE-UP OF DOTSON HOLDING NATE'S LAST PIECE OF SCULPURE, A FROG'S HEAD.	**He was working on this frog's head, when his heart failed and he died at 52.**	

ALISSA NICHOLLS, NATE'S DAUGHTER, READING HER DAD'S POETRY WITH SISTER HEATHER LEANING OVER HER SHOULDER AND BROTHER JOSH LEANING AGAINST PICNIC TABLE LISTENING	"There really isn't much difference between this old man and a chunk of rusty mooring chain."	*Alissa looks up while reading her dad's poetry aloud, so we cut to what she can see, a sculpture made out of "a rusty mooring chain," matching pictures to words.*
FAMILY PHOTO OF NATE NICHOLLS, HALF DISSOLVE TO COLORFUL FLOWERS MADE OUT OF FAUCET HANDLES	**[NARRATION]** **Nate's children buried him this fall beneath flowers he made from water faucet handles.**	*Once again, I tell the viewer what they can't see. Those colorful faucet handles mark a grave. That's writing to the corners of the picture.*
DOUGLAS GEIS TWIRLING ARROW CHIMES	NAT SOUND: TINKLING CHIMES	
BOB DOTSON WALKING WITH HEATHER NICHOLLS, NATE'S DAUGHTER. THEY PASS SCULPTURES PROPPED IN A FOREST GLEN. BOB ASKS:	"What inspired your dad to fill these woods with art?"	*Heather first revealed this off-camera. I asked her to repeat it while we walked past some of the larger sculptures. That way we could add a stunning turning point in a visual setting.*
HEATHER NICHOLLS	"Originally, the city had told him that he had too much junk collected, so he decided to turn it all into art."	

DISSOLVE FROM PILE OF DISCARDED JUNK TO GEAR HEAD		
CLOSE-UP OF GEAR HEAD. EYES MADE OF MARBLE. EARS MADE OUT OF PRESSURE GAUGE	**[NARRATION]** **"Fine" art—for his grandchildren to discover.**	*Pointing out a detail to the kids also shows the viewer.*
BOB DOTSON, CORN IN HIS HAND	VOICE OVER "That corn is made out of bolts and screws."	
ROOSTER SCULPTURE WITH SAW BLADE CROWN	**[NARRATION]** **Not all of his sculptures are easy to spot.**	
ARMY OF SMALL RAILROAD TIE FIGURES MARCHING THROUGH GRASS	**Some are just three inches tall.**	
SCULPTURE OF FROG ZAPPING FLY; BARRETT NICHOLLS DISCOVERS IT. HE JUMPS UP AND SHOUTS GRRRR.	NAT SOUND: GRRRR	*The little boy pouncing on small sculptures that I don't see sets up the joke line in the next scene. Most jokes need a set-up to be funny.*
BOB DOTSON ASKING QUESTION OF DOUGLAS GEIS:	"Why do you see so much that I can't see?"	
DOUGLAS GEIS:	"Because you can't see without your glasses."	
CAMERA SWINGS TO BOB LAUGHING.	"(LAUGHING) Maybe."	

INSIDE NATE NICHOLLS'S HOME. TILT DOWN COLORFUL PAINTINGS ON STAIRWAY WALL TO EYE OF JOSHUA TREE	**[NARRATION]** **All of us hope our lives hold something of value. The man who painted this left more than a forest full of art.**	*In this TILT DOWN, the camera moves down the scene. I take the viewer inside Nate's house to show his beautiful oil paintings hanging everywhere. They prove visually that Nate was more than a craftsman, an important reminder at the end of the story.*
NATE'S GRANDKIDS INSIDE HIS HOME, CREATING ART WITH PLAY-DOH	**The BEST of Nate Nicholls—lives on in them.**	
DOUGLAS GEIS	NAT SOUND: "I made a volcano shooting lava."	
TIME-LAPSE SHOT OF DEER AND CATERPILLAR SCULPTURES IN NATE'S FRONT YARD, CLOUDS MOVING RAPIDLY ABOVE HIS HOME	**[NARRATION]** **Nate's family has moved some of his sculptures up next to their home near Waldoboro, Maine.**	
	BOB DOTSON IN-STUDIO: YOU'RE WELCOME TO STOP FOR A CLOSER LOOK AT THE LEGACY OF A MAN WHO COULDN'T AFFORD TO BUY FINE ART, BUT HAD THE VISION TO MAKE IT.	

http://www.today.com/video/today/57024491

FIND A STRONG CENTRAL CHARACTER

Interesting characters help sell stories. Another way to get started is to look for articulate people who will intrigue your audience. Viewers relate to ordinary people who can help them understand issues and events. The best characters pull the viewer into the story. I was covering a Grade C tornado one day. No deaths, no injuries, a mobile home smashed. The kind of natural disaster that leaves little to shoot.

Other reporters spent most of their time trailing after the mayor who said—predictably—"We need some assistance here."

Sound bites like that are quick, easy, sure things. But everyone gets the same bite.

You can do better. Let the mayor and your competitors go one way. You go another. Pick up official quotes from the mayor's press office. If they have substance, you can add them to your script.

We followed a man in bib overalls searching through the remains of his mobile home. I introduced myself. Began to visit as he continued to look. Another reporter ran by, trying to find the mayor.

"What was the tornado like?" shouted the passing reporter.

"It sounded like a freight train," our guy mumbled.

The reporter ran on. I stayed.

The man finally found what he was looking for.

Pictures?

No.

A big hunk of pink goo. He pulled it out of the muck, put it next to his face and smiled a toothless smile.

"Well, it got my teeth, but it didn't get me!"

Bingo! I had my close. Now, I could spend the next 20 minutes finding elements that would build to that close. No need to interview 19 more people. We could weave the bib overall guy's search throughout the spot.

Everybody else went after those 19 sound bites but gave scant attention to the people who gave those quotes. The man in the bib overalls became the thread that held together our entire piece.

Viewers relate to people who can tell their tale with passion. A strong central character helps them understand the story you have to tell.

SCRIPT #6: PARK AVENUE PEELER

In this story, we found a pied piper whose dynamic personality attracts viewers and helped us lead them through the story. Joe Ades sells enough five-dollar potato peelers to live on Park Avenue, one of the most expensive streets in America. But his charm alone cannot carry the story. Like a great singer, the strong central character needs good backup. Bob Kaplitz has developed the world's largest on-demand library of learning videos for multimedia journalists, www.kaplitzblog.com. Here he takes a close look at this story's construction:

ANCHOR INTRODUCTION:
TODAY'S *AMERICAN STORY WITH BOB DOTSON* COMES FROM ONE OF THIS COUNTRY'S BEST-KNOWN ADDRESSES, HOME OF SOME OF THE WEALTHIEST PEOPLE ON EARTH—AND A MAN WHO'S MADE A FORTUNE SELLING ON STREET CORNERS.

VENDORS SETTING UP GREENMARKET AT UNION SQUARE IN NEW YORK CITY

NAT SOUND: MUSIC

Dotson begins with a variety of edited pictures in the opening. Light-hearted music sets the tone. First line of narration matches the video, which shows a garden of vegetables.

[NARRATION]
In the garden of life, big things can grow from small beginnings, provided you use enough fertilizer.

A DAPPER OLD MAN, DRESSED IMPECCABLY IN A THOUSAND-DOLLAR SUIT, SQUATS ON A STREET CORNER, TALKING TO HIMSELF, APPARENTLY ABSORBED IN THE JOY OF PEELING CARROTS AND POTATOES. HE LOOKS UP AT GAWKERS WHO HAVE STOPPED TO SEE WHAT HE'S DOING, THEN WAVES THEM CLOSER.

NAT SOUND:
"Come on. Don't worry. I won't ask you for money."
[NARRATION]
Joe AH-des could talk a starving dog off a meat truck.

Note the succinct writing leading to natural sound.

CLOSE-UP OF JOE'S FACE	NAT SOUND: "Now come around the front. I'll show you how this works."	
JOE DEMONSTRATES THE POTATO PEELER.	**[NARRATION]** **The man in the thousand-dollar suit sells five-dollar potato peelers.**	
SHOT OF TWO WOMEN [TWO SHOT] WHO HAVE STOPPED TO LOOK	NAT SOUND: "Very cool."	
CUSTOMER DANGLES DOLLARS IN JOE'S FACE, TRYING TO GET HIS ATTENTION. HE IGNORES HER.	**[NARRATION]** **Lots of them.**	
GLAMOUR SHOT OF BEAUTIFUL APARTMENT. JOE LEADS BOB DOWN A BEAUTIFUL HALLWAY FILLED WITH ART AND TURNS INTO THE MAID'S ROOM. BOB ASKS: JOE ADES	**You won't believe his warehouse.** "So where do you keep the potato peelers?" NAT SOUND: "Right in here." **[NARRATION]** **Boxes and boxes . . .**	*The video is not static, which would slow the pace of the story. The camera keeps moving, following action.*

ANOTHER APARTMENT GLAMOUR SHOT	**. . . in his Park Avenue apartment.**
BOB TELLS GAWKER, VICTORIA TILEY, WHO IS WATCHING JOE DEMONSTRATE THE POTATO PEELER.	
VICTORIA TILEY	NAT SOUND: "Really?!!!"

Note use of natural sound to underscore this point. Victoria Tiley, one of the people watching Joe work, is amazed at the revelation. Her natural sound gives the viewer time to react, too.

PARK AVENUE STREET SIGN	**[NARRATION] Yep. Park Avenue.**
JOE ADES	"Never underestimate a small amount of money . . ."
QUICK CUT MONTAGE OF MONEY CHANGING HANDS	VOICE OVER ". . . gathered by hand, six days a week—for 60 years."
LOW-ANGLE SHOT OF JOE TALKING TO THE CROWD	NAT SOUND: "Now why would you buy four peelers if they last a lifetime? Because you have four friends. That's why."

JAZZ PLAYERS	NAT SOUND: PIANO MUSIC GREEN DOLPHIN STREET	*Dotson inserts a bit of music before beginning his narration again. Music is an effective transition too. Here it allows the viewer time to think about what Ades has just said.*
JOE WALKING AROUND ART GALLERY	**[NARRATION]** **Joe's business makes him something of a mystery man in this posh neighborhood.**	
KATHLEEN LANDIS	"Some people suspected he might be Sean Connery."	
MAN PULLS PEELER ACROSS CARROT.		
GAWKER, FRANK ROSADO, WATCHING JOE AT WORK	NAT SOUND: JOE "Just pull the handle, just try it."	
	NAT SOUND: ROSADO "He's got an English accent, but he's probably from Mobile, Alabama. Who knows?"	*Joe is framed in the background of the person being interviewed. Dotson waited to ask his questions until the photojournalist had this composition, a visual reminder of who the interviewee is talking about.*

FILE FOOTAGE OF WORLD WAR TWO BOMBING	NAT SOUND: EXPLOSION MIXED WITH PERIOD MUSIC	*Note the explosion and music rivet the viewer's attention. File video is often dull; editing with graphics can make it more interesting.*
	[NARRATION] **The accent is as real as the bombs in his boyhood backyard. Joe grew up in Britain during World War Two, learning from pitchmen who set up in the rubble.**	
JOE ADES JOE ADES	"Joe Squinters, Black Dougie, Heckle and Peckle." "They were brilliant."	*The editor used a shot of Bob laughing. A reaction shot of the interviewer underscores the emotion of the moment.*
JOE SHOWING BOB A PHOTO TAKEN AT BLACKPOOL, ENGLAND, WHEN JOE WAS JUST STARTING TO SELL	**[NARRATION]** **And so—it turned out— is Joe.**	*See how the line of narration completes the comparison? Remember you can tighten scripts by using natural sound as part of your writing.*
CLOSE-UP SHOT OF JOE'S HAND BRUSHING ACROSS THE PHOTO	NAT SOUND: "Big crowd!"	

BOB DOTSON	"What's the most unusual thing you've sold?"	
JOE ADES	"(JOE PONDERS HIS ANSWER) Unusual? Ah, Christmas trees in February. (LAUGHS) I'm not kidding!"	*Thoughtful questions elicit memorable quotes.*
LAYER IMAGES OF OLD-FASHIONED CHILDREN'S BOOKS OVER SHOT OF JOE AND RUTH WALKING DOWN STREET	**[NARRATION]** **Joe taught his daughter, Ruth, how to hawk children's books on the street, so she could put herself through Columbia University.**	
BOB DOTSON	"What's the key to your dad's success?"	*Note Joe adds his own thoughts to his daughter's answer, the result of a question that was implied, but never asked.*
RUTH ADES-LAURENT	"Tenacity and patience."	
JOE ADES	"I think that's the secret of happiness. Not doing what you like, but liking what you do."	
NEW YORK SCENICS	NAT SOUND: MUSICAL TRANSITION	
BOB DOTSON APPROACHES A GRAND STAIRCASE THAT SPIRALS UP LIKE PIANO KEYS, ALL BLACK AND WHITE:	**STAND-UP COPY** **Joe has had the kind of life most of us only see in movies, but he wanted to share it with someone. So he took out an ad, looking for a new wife. His fourth. He got 600 proposals and picked three "maybes." The next evening he met the woman he would marry. She had *not* seen the ad.**	*Pick a stand-up location that matches the story. Build to a powerful punch line.*

SIDE SHOT PROFILE OF JOE LOOKING AT A PHOTO OF HIS WIFE, ESTELLE	NAT SOUND: "Ah, that was the happiest time of me life with my late wife, Estelle."	*Nostalgic natural sound adds depth to the story and a deeper understanding of Joe.*
	[NARRATION] She died of breast cancer last November.	
TILT DOWN FROM THE TOP OF A HIGH-RISE BUILDING TO THE SIDEWALK CAFÉ WHERE JOE IS EATING WITH HIS FAMILY	**[NARRATION] Now, he works for the other women in his life. His granddaughters.**	*Note the use of an establishing shot that shows where the scene takes place.*
JOE AND HIS GRANDCHILDREN EATING DINNER. NINA SAYS:	NAT SOUND: "Me and my friends went to a river and caught minnows!"	*The photojournalist puts the camera at table level to make viewers feel like they are part of the dinner conversation.*
JOE ADES	NAT SOUND: "Minnows!"	
SHOTS OF FAMILY BEING SERVED AND KIDS' FACES	JOE ADES VOICE OVER "I want the kids to go to the best colleges that it's possible to go to. And I want to pay for it."	*Joe's sound bite placed here to sum up why he is still working hard in his 70s.*
LOADING POTATO PEELERS ON HIS CART AND HEADING OUT THE DOOR	**[NARRATION] That's why Joe is up before dawn every day.**	*Note: "That's why" brings us back to where we started. This is called bookending a story.*

PUSHING CART ACROSS PARK AVENUE	**[NARRATION]** **At 74, still pushing potato peelers down Park Avenue.**
BOB DOTSON	"Do you ever take a vacation?"
JOE ADES	"Life is a vacation. (LAUGHS) Every day is a vacation."
POURING CHAMPAGNE, SLOWLY DISSOLVE TO NEW YORK CITY SCENICS	**[NARRATION]** **. . . to be savored. For *Today*, Bob Dotson, NBC News, with an *American Story* on Park Avenue.**

At the end Dotson uses a mix of video, music and natural sound to make New York City look like a vacation paradise. This editing visually reinforces Joe's philosophy. Joe believes he's playing when he works.

http://www.today.com/video/today/57024532

FIND INTERESTING STORIES AND PEOPLE TO INTERVIEW, EVEN WHEN TIME AND MONEY ARE TIGHT

As the preceding script made clear, Joe Ades was far more than what he sold. But how do you go about *finding* a Joe Ades? Be curious about seemingly ordinary lives. Don't pass them by. They are folks nobody bothers to talk with in depth, the ones who lead lives with extraordinary passion that inspire the novels that get made into movies, that actors star in, so the media can interview them, about the people they portray.

Give ordinary people the same investigative scrutiny as you would the mayor or city council. You'll be surprised what you uncover. For instance, there's a Living Ghost Town in Montana. Like a lot of small towns, it

seemed destined to fade away. But Philipsburg still stands because people found a way to save the place they love. This story does more than trumpet their achievement. It is a blueprint that shows how they did it.

SCRIPT #7 LIVING GHOST TOWN

ANCHOR INTRODUCTION:
THIS MORNING'S *AMERICAN STORY WITH BOB DOTSON* TAKES YOU TO A LIVING GHOST TOWN THAT THE NATIVES WON'T LET DIE.

HORSES SCRATCHING THROUGH SNOW, LOOKING FOR BREAKFAST, AT SUNRISE. DISSOLVE TO ISOLATED CABIN AND ZOOM OUT TO BIG, BEAUTIFUL SKY.	NAT SOUND: MIXED WITH MUSIC **[NARRATION]** **In this high mountain valley, far from the rest of us, is the kind of place America used to hear about. Where people survive without federal aid or giant corporations.**	*Set the scene.*
PHILIPSBURG TOWN SHOT	NAT SOUND: TOWN CLOCK CHIMES "Bong. Bong." **[NARRATION]** **Philipsburg, Montana, is a . . .**	

COFFEE SHOP—CAMERA SHOOTING THROUGH HALF-FULL COFFEE POT—GREAT FACES, WORKING MEN	**. . . working class town that gets things done the pioneer way—together.**	
		What kind of people live here? That's important. They foreshadow the story to come.
JIM JENNER'S FACE	JIM JENNER VOICE OVER "They're tough people. . . ."	
ON CAMERA	" . . . This is tough country. Tough jobs, like mining, and they believed in the future."	
MONTAGE OF OLD PHOTOS	NAT SOUND MIXED WITH MUSIC **[NARRATION] Even when the mines boomed and busted. Jobs came and went. Dreams soared and shattered.**	*What did they do when faced with life's setbacks?*

DOTSON WALKING IN NEIGHBORHOOD OF OLD VICTORIAN-ERA HOMES	**STAND-UP COPY** **Philipsburg has always attracted people with intensity and drive. Its pioneers beat everyone to Montana's first silver mine, then built 30 houses in 30 days! This place is like a forge and the people who live here have spirits of hammered steel.**	*Stand-up copy offers proof of their determination.*
COMIC ACTRESS SLAPS ACTOR, THEN THEY KISS AND SHE SLAPS HIM AGAIN. THEY ARE PERFORMING IN A BEAUTIFULLY RESTORED OPERA HOUSE.	NAT SOUND: SLAP **[NARRATION]** **How else could a town of 900 build its own opera house?** NAT SOUND: PERFORMANCE **[NARRATION]** **Or produce two *original* plays each year?** NAT SOUND: SECOND SLAP	*Note the transition. The slap is here to bring viewers' attention back to the screen.*

SORTING CLOTHES IN THRIFT SHOP	**[NARRATION]** **Performers get costumes from the local thrift shop, where neighbors sell hand-me-down clothing and housewares.**	
WOMAN PICKS UP BOWL	NAT SOUND—(CUSTOMER) "Six? That's a deal!"	
WOMAN BUYING CLOTHES IN THRIFT SHOP	**[NARRATION]** **The money,** NAT SOUND: CASHIER "There you go." **. . . more than a million dollars,**	*Now a series of surprises meant to underscore the townspeople's ingenuity.*
PATIENT LIFTING LEG WEIGHTS IN EXAMINING ROOM	**. . . helps keep the town's hospital running,**	
HOSPITAL EXTERIOR	**. . . which the state once threatened to close.**	
POSTAL WORKER PLACING TAPE ON BOX	NAT SOUND: TAPE RIPPING **[NARRATION]** **People here closely guard the things that make a town a town.**	

TOWNSPEOPLE CHIT-CHATTING IN POST OFFICE	**The post office is *the* one place—every day—where people can check on each other.** NAT SOUND: NEIGHBOR TALKING TO JUDY PAIGE "Horses are good. Cows are good."	*Why they do what they do. The following example is here to prove how effective they've been.*
EXTERIOR OF POST OFFICE	**[NARRATION]** **So when the federal government tried to move Philipsburg's post office . . .**	
JUDY PAIGE BUYING STAMPS AT POST OFFICE	NAT SOUND: PAIGE TALKING TO POSTAL WORKER "I'm going to need some Christmas stamps." **[NARRATION]** **. . . Judy Paige led a successful fight to keep it downtown.**	
JUDY PAIGE	"We were afraid that this town was going to become another ghost town!"	*I picked this quote (sound bite) because it touches on the reason we did this story. Judy's quote leads us to images of the ghost towns that surround Philipsburg. It's placed here as a transition.*
GHOST TOWNS	**[NARRATION]** **Like the 29 nearby that have disappeared.**	
SUNRISE WITH FENCE IN FOREGROUND	**Fewer than two people per mile now live in the valley around Philipsburg.**	

SCHOOL BELL RINGING; SCHOOL BUS PULLS UP TO CENTURY-OLD SCHOOL	NAT SOUND: RINGING **[NARRATION]** **Only 100 kids go to its elementary school.**	
MIKE CUTLER TALKING TO KIDS IN SCHOOL LUNCHROOM	NAT SOUND: CUTLER "Megan, did you lose some teeth?"	
MEGAN LOOKS UP	**[NARRATION]** **Yet, Superintendent Mike Cutler points out . . .**	
KIDS SWINGING ON PLAYGROUND, SHOWS SCHOOL BEHIND	**. . . that people taxed themselves a bunch to restore it . . .**	
BANK TELLER COUNTING MONEY FOR CUSTOMER	NAT SOUND: TELLER "Twenty, forty—" **. . . an average of 25 hundred bucks a person.**	*Note the line of narration plays off the natural sound of teller counting money.*
MIKE CUTLER ON CAMERA	"This is what we do, and if it's not good enough, we'll make it good enough."	
BOB DOTSON	"Why do you suppose this town has survived, when so many other small towns in this country have not?"	
MIKE CUTLER	"It's the last best place. It truly is. And it doesn't have any choice but to survive."	*The superintendent's poetic answer is put here to foreshadow what happens to him.*

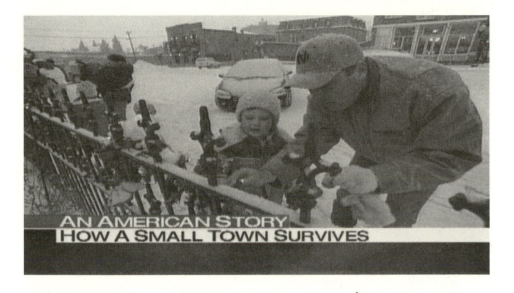

AN AMERICAN STORY
HOW A SMALL TOWN SURVIVES

| LITTLE BOY SCREAMS AND PLUNGES OFF CLIFF, LANDING IN A PILE OF SNOW. | NAT SOUND: DELIGHTED SCREAM
[NARRATION]
The town has been successful, so far, because survival is put ahead of personal gain. | *This moment of natural sound gives the viewer time to think about what the superintendent has said. I picked a child's happy, laughing face to reinforce his point.* |
| MIKE HELPING HIS DAUGHTER HANG CHRISTMAS DECORATIONS DOWNTOWN | **Two years ago Mike Cutler was diagnosed with cancer, leukemia.** | |

TIGHT SHOT OF ORNAMENT BEING HUNG	**He needed a costly stem cell transplant.**	
DISSOLVE TO MIKE CUTLER	"And here's this great big tent. You know? Like you see at the circuses. And I could not believe the amount of people."	*This surprise is placed here to prove why the town has been so successful.*
BOB DOTSON	"How much money did they raise?"	
MIKE CUTLER	"Close to forty thousand dollars."	
BOB DOTSON	"There are fewer than one thousand people in this area."	
MIKE CUTLER	"Yes. It was overwhelming for me. Still is."	
JODY CUTLER PUTS DAUGHTER, SYDNEY, ONTO SNOWMOBILE BEHIND HER BROTHER AND FATHER. THEY ALL TAKE OFF IN A CLOUD OF SNOW AND GIGGLES.	NAT SOUND: SYDNEY'S DELIGHTED SCREAM **[NARRATION]** **This Christmas, Mike is cancer free.** NAT SOUND: JIM CUTLER "Hold on, dad's a crazy driver! Ready?" NAT SOUND: KIDS "OOOOOOOOooooooooooooo!"	*Note that the emotional interview is followed by a child's scream of delight, both foreshadowing the next surprise and lightening the mood.*
DISSOLVE TO TOWN SHOTS	MIKE CUTLER VOICE OVER "I've won that battle, with the town of Philipsburg on my shoulders. Helping me."	

CHAPTER 4

I'M SORRY THIS STORY IS SO LONG. I DIDN'T HAVE TIME TO WRITE A SHORT ONE.

YOU aren't ready to write a story until you can state in one sentence what you want the audience to learn from your report. You should be able to answer that in a complete sentence with a subject, verb and object:

- "Outside money is altering the city's architecture."
- "This cow has never taken an order in her life."
- "You can't murder a pumpkin."

Prove the points visually. Very seldom will you state the point of your story verbally.

PICTURES COME FIRST

Pictures are powerful storytelling tools. "Write" them first. Think how the pictures should progress in your story. Remember, there is a language of video, just as there is of words. They must both flow—one to the other—logically and smoothly. Resist writing words first, then using pictures to cover those words like wallpaper. That is rarely the most compelling way. If you are not personally shooting the pictures, ask the person who did four questions:

1. "What's the best video you have to open the story?"
2. "What moment gave you a lump in the throat?"
3. "What main points of the story don't have video?"
4. "What's the most powerful picture for the close?"

WRITE THE MIDDLE OF YOUR STORY NEXT

Don't sit in front of your laptop and anguish over an opening line. The middle part of the story is the easiest place to start. It will be chock-full of facts that are right in your notebook or on your cell phone. There is an added benefit to beginning in the middle. If the producer calls out, "I need a shorter version," you can cut without destroying the opening or close.

In the main body of the story, concentrate on crafting three to five key points, which you support visually once you have identified them. Make them as clear and sharp as you can, so they'll cut through the clutter and stick in the viewer's memory.

ASK YOURSELF, "WHAT DOES THIS STORY MEAN?"

Writing the middle of your story first will help you find the HEY, the YOU and the SEE. Now step back and ask yourself, "Is there more here than meets the eye?" For instance, why do children on a small island off the coast of South Carolina write wonderful poetry?

"Life changes slowly. There are no paved roads, no streetlights, and no bridge to the outside world. This island is so remote, the mind can be your best friend."

Those 28 words tell a great deal. You can too, when you ask, "What am I seeing here that is not obvious?" Answer that and you'll find the SO in your story.

DON'T THROW AWAY THOUGHTS

When sound bites prompt ideas, write them down. Carry an extra notebook in your back pocket or type them into your cell phone. Those

thoughts may not always fit the story you've been assigned, but don't throw them away. The next time you're pressed for an opening line, take out that notebook or scroll through those lines you saved on your phone. One of them might prompt the perfect opening narration.

My "Ideas Notebook" has saved me many times. Once I was sent through the night to do a story on an explorer who was injured and trapped in the bottom of a cave. I had no chance to interview her rescuers. They were pulling the explorer from the earth when I arrived. Our live shot location was twelve *miles* from the mouth of the cave. Fortunately, our editors in New York already had cut a core spot from the video rescuers had shot.

During my flight to New Mexico, I talked constantly with the producers who were logging the video. We determined there was a larger story to be told. Emily Mobley was injured in an unmapped part of that cave. Lost in the darkness. What would have happened to her without friends, all of whom were world-class cavers? "Darkness" and "Friendship" seemed to be the keys to this story. I flipped through my Ideas Notebook, reading every thought I'd ever jotted down about those two words. The following script emerged from the ideas I sketched out on the plane ride to New Mexico.

SCRIPT #8: CAVE RESCUE

| BOB DOTSON LIVE WRAP OPEN | **Imagine slithering through a cave—a mile and a half long— climbing up a thousand-foot maze dragging a broken leg. That's what it was like for Emily Mobley for four days, after an 80-pound boulder slipped and crushed her in the cave.** | *When a reporter appears live on camera to open and/or close a story shot on location, that is called a Live Shot with Core Video [LWC], LIVE WRAP for short.* |

TO CORE SPOT VIDEO: BEGINS WITH NATURAL SOUND OF RESCUE

[NARRATION]
Shadows chasing shadows. Now and then a whisper of sliding rope; the anxious, uneven breathing of 60 people lugging one of their own.
NAT SOUND:

One of the rescuers said they always made sure Emily could see a light above her. That prompted the opening line. I asked the editor if he had usable natural sound. He said, "Yes." Told me what could play sound up. I stopped narrating now and then to showcase that natural sound. It enhanced the viewers' experience. Put them in the cave.

[NARRATION]
Emily Mobley was at the bottom of one of the deepest caves in the United States—Letch-ah-gee-YAHA cavern. So big there were explorers at the opposite end that didn't even know the four-day rescue took place.

How big was the cave? Rescue footage didn't show that. We had no time to order a graphic map, so I wrote the "didn't even know" line to evoke the vastness of this dark place.

NAT SOUND:
[NARRATION]
The darkness would have been total for Mobley without her friends.

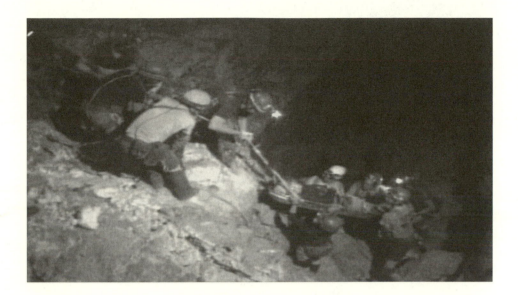

NAT SOUND:

[NARRATION]

They lugged her to the top an inch at a time. One and a half miles. In places they cushioned her weight with their own bodies and always kept a light for her to see above.

How difficult was the rescue? We know the place was big. Writing this line here reveals how painfully slow that rescue was. It also foreshadows the rescuers' commitment to Emily.

NAT SOUND:

[NARRATION]

Mobley was mapping the cave near Carlsbad, New Mexico, when a loose rock started this test of friendship.

NAT SOUND:	*It struck me how quickly*
[NARRATION]	*Mobley's friends had*
Pals came from all around	*come to her rescue.*
the country. A cry of need	*That's why I wrote the*
seems to carry farther in the	*line:*
darkness, or perhaps we listen	*A cry of need seems*
closer.	*to carry farther in the*
	darkness, or perhaps we
	listen closer.
NAT SOUND:	*Place names are put*
[NARRATION]	*here to heighten the*
They pulled her past places	*fear rescuers felt. I asked*
called Freak Out and Night-	*the editor if the camera*
mare. Finally, carried her out	*person had taken a*
into the night, where the light	*picture of the moon. He*
above . . .	*said, "Yes." So I wrote*
	that "did not need bat-
SHOW FULL MOON **. . . did not need batteries.**	*teries" line.*

http://www.today.com/video/today/57024661

HIGHLIGHT A STORY'S NATURAL DRAMA

Don't overlook a story's natural drama. If you're covering the demolition of a building and cut to the explosion a split second before, that's not nearly as dramatic as when you build in a pause before the blast.

Often, when news producers tell us to tighten stories, we end up chopping everything, including the story's natural drama. Write tighter in other parts of your piece to save time for the dramatic part to play itself out.

For example, if a hundred-year-old man hits a ball during a softball game and runs to first base, don't cut away to another shot. It's more dramatic to see—in real time—whether he can make it. Every good story should have a bit of drama. Stringing facts together is not enough.

WORKING FAST

That cave rescue story was scripted quickly. Under deadline. How do you write a longer, thoughtful story at the speed of spot news? Writing a longer story requires an entirely different form from day-to-day news. You must build each segment with a cliffhanger ending, enticing viewers to stay tuned.

I got a note from an assignment editor one day. All it said was "Go do a piece on Ruby Bridges. She's a civil rights activist who's speaking today at her old elementary school." Well, I'd never heard of Ruby Bridges, but I suspected I already knew what she had to say. The struggle for civil rights is a familiar story. How could I get an audience to listen one more time? I found out that the key was to remind viewers what it is like to be six. Read the script. Afterward, I'll show you step by step how we gathered the video elements we needed and why the story was edited this way.

SCRIPT #9: RUBY BRIDGES

ANCHOR INTRODUCTION:
THOUGH YOU MAY NOT
RECOGNIZE HER NAME, YOU'VE
PROBABLY SEEN A PORTRAIT OF
HOW RUBY BRIDGES LOOKED
WHEN SHE WAS SIX. THAT LITTLE
GIRL HELPED TO MAKE A BIG
CHANGE IN THIS COUNTRY.
THAT'S TODAY'S *AMERICAN
STORY WITH BOB DOTSON*.

RUBY BRIDGES WALKS INTO FRAME AND PEERS OUT A DUSTY WINDOW. SHE WATCHES CHILDREN ON THE PLAYGROUND BELOW. CAMERA SLOWLY ZOOMS IN TO HER FACE.	NAT SOUND AND MUSIC **[NARRATION]** **Ruby Bridges is back in the classroom that was once her prison.**
RUBY BRIDGES	"I remember staring out of that window because it looked right over the playground, this 'huge' playground (POINTS TO THE TINY PLAY AREA BEHIND THE SCHOOL) that I was never allowed to go out and play on."
SLOW DISSOLVE TO BLACK-AND-WHITE FILM FROM 1960— CROWD CHANTING	NAT SOUND: "2, 4, 6, 8. We don't want to integrate."
BLACK-AND-WHITE FILM FROM 1960— CROWD WAVING CONFEDERATE FLAGS	**[NARRATION]** **In the fall of 1960 there was a mob out there.**
RUBY BRIDGES	"They were shouting and pointing and I didn't quite understand why they were so angry."

BLACK-AND-WHITE FILM FROM 1960— SIX-YEAR-OLD RUBY ENTERING SCHOOL. U.S. FEDERAL MARSHALS SURROUND HER.	**[NARRATION]** **Ruby was just six.** NAT SOUND **Chosen to desegregate this New Orleans school. Alone.**
BLACK-AND-WHITE FILM FROM 1960— ANXIOUS AFRICAN-AMERICAN MOM LOOKING AT SCHOOL. A SEA OF WHITE FACES SURROUND HER.	
RUBY BRIDGES	"When I first drove up to the school, I actually thought it was Mardi Gras. (GIGGLES) You know. Living here in New Orleans. The crowd outside. They were barricaded. And they were throwing things. I kinda felt like I was in the middle of a parade."
BLACK-AND-WHITE FILM FROM 1960— LITTLE RUBY TRUDGES ALONG WITH HER LUNCH BOX.	**[NARRATION]** **The youngest soldier in the struggle for civil rights.**
PAINTING SHOWS LITTLE RUBY SITTING AT HER SCHOOL DESK.	**She went to her classroom.**

RUBY BRIDGES	"And it was empty. (CHUCKLES) So my first thought was, 'I'm too early.' (LAUGHS)"
BLACK-AND-WHITE FILM FROM 1960— WHITE FATHER RAISES HIS CHILD'S HANDS TO THE CROWD AND THEN TURNS FROM THE SCHOOL DOOR.	**[NARRATION]** **All the other parents had taken their children home.**
RUBY BRIDGES	"And there were no kids there. Just all these empty desks. And that stayed that way the whole year."
BOB DOTSON	"Does this hallway bring back lonely memories?"
RUBY BRIDGES	"I was never allowed to walk these halls. Once I got in the classroom, that's where I stayed."
PAINTING SHOWS RUBY AND HER TEACHER.	**[NARRATION]** **With her teacher. But Ruby never missed a day.**
BLACK-AND-WHITE FILM FROM 1960— WHITE CHILDREN, RETURNING TO SCHOOL, WALK PAST SCREAMING CROWD.	**Gradually, other kids did come back.**

RUBY BRIDGES

"I would say to my teacher, 'I hear children.' And then one day, she opened this door that led from the coat closet that connected to this other room. There were five or six white kids. I thought, 'Oh my God, look at this!' I felt like I had just stepped into Disney World."

BLACK-AND-WHITE FILM FROM 1960—WHITE DEMONSTRATOR ARRESTED

BOB DOTSON WALKING IN NEIGHBORHOOD NEXT TO THE SCHOOL

STAND-UP COPY
The curses and crowds finally faded away, but Ruby's family had paid a terrible price. Her father lost his job. Her parents divorced. Ruby stepped into history's shadow.

STAND-UP COPY CONTINUES OVER CUTAWAY OF SCHOOL CROSSING GUARD WHISTLING TRAFFIC TO A STOP. CHILDREN WALK TOWARD SCHOOL.

Ruby stepped back into the spotlight, determined to help other children who have problems.

A CUTAWAY shot interrupts the video action by inserting a view of something else.

CLOSE-UP SHOT OF
STOP SIGN.
WIDE SHOT OF RUBY
ENTERING SCHOOL
TODAY WITH A GROUP
OF SIX-YEAR-OLDS

RUBY BRIDGES	"I think it's important that we become mother and father to every child." **[NARRATION]** **She began with the children in her old school—Frantz Elementary.**
RUBY READING TO GROUP OF SIX-YEAR-OLDS	"It shouldn't matter that Gerald is not the same color as you."
BOY	"No, we're still friends."
	[NARRATION] **Ruby Bridges was too young to be bitter the first time she was here. Too wise to be bitter today.**
RUBY BRIDGES	"We have to spend a lot more time with our kids, making sure that they are not faced with those same things that this (POINTS TO HERSELF) six-year-old was faced with."

FAMOUS NORMAN ROCKWELL PAINTING, A LITTLE GIRL WEARING A WHITE STARCHED DRESS WALKS BENEATH A SCRAWLED CURSE, A CRUSHED TOMATO AT HER FEET; FEDERAL MARSHALS SURROUND HER, ONE WITH A COURT ORDER IN HIS POCKET. THAT LITTLE GIRL IS RUBY BRIDGES.	NAT SOUND MIXED WITH MUSIC **[NARRATION]** **Ruby Bridges' proud march inspired Norman Rockwell's most powerful painting. He called it "The Problem We All Live With."**
RUBY HUGGING A GROUP OF SIX-YEAR-OLDS	**This little girl of six was able to do what she did because her heart and mind were wide open. Ruby's mission today is to keep other hearts and minds from closing.**
RUBY BRIDGES TALKS TO CHILD ON HER KNEE.	"Make sure you tell somebody about the story."
	[NARRATION] **For *Today*, Bob Dotson, NBC News, with an *American Story* in New Orleans.**

http://www.today.com/video/today/57024582

The long-form feature or magazine piece requires a structure far different from the short news story. You must use all the tools of a good novelist:

- Scene setting
- Foreshadowing
- Conflict
- Character growth
- Resolution

Let's take them one at a time.

SCENE SETTING

We knew that Ms. Bridges would want to see the classroom *"that once was her prison."* I discussed that with the camera crew. We decided that they would go in ahead of her and use minimal lighting, so as not to distract from the moment. Ms. Bridges' old classroom had not changed much in 40 years. It still had the tall windows where she had watched the screaming mobs. We figured that's where she would go first—to look and remember.

Cameraman Rob Kane chose a wide-angle lens shot, the better to set the scene. Soundman Corky Gibbons placed a microphone near the bottom of the classroom door to record the click when Ms. Bridges entered and her footsteps echoed across the floor. He already had put a wireless microphone on Ms. Bridges when they first met, the better to record any quiet comments she might make as she wandered the room.

We were looking for a four-shot sequence:

1. Wide shot of the classroom
2. Tight shot of her feet
3. Over-the-shoulder shot as she looked out the window
4. Low-angle shot of her face

Three of those shots would be easy to get in sequence—wide, over-the-shoulder and face—but the cut-in shot of the feet would have to come later. The camera could not be in two places at once. That close-up video of her feet would be important to help us edit. Cutting to the feet would shorten the time it took Ms. Bridges to walk from the door to the window. How did we get that shot? Rob waited until Ms. Bridges started looking around the room again, then put his camera down at floor level and moved it until her feet were walking right to left in his viewfinder, the same direction she had been walking in the wide shot.

That four-shot sequence allowed us to introduce the black-and-white historical footage in context. As Ms. Bridges looked out the window at the children below, we half-dissolved to the old film, framed in the window. Our scene-setter uses all the video tools.

- *Natural Sound:* Door click and footsteps
- *Narration:* "Ruby Bridges is back in the classroom that was once her prison."
- *Picture:* Old classroom virtually unchanged
- *Graphics:* Black-and-white film of Ms. Bridges' ordeal framed in the picture window
- *Editing:* Four shots to build pace into the opening

FORESHADOWING

We give a hint of what's to come early in this story—the first line and opening sound bite:

> **[NARRATION]**
> **Ruby Bridges is back in the classroom that**
> **was once her prison.**

RUBY BRIDGES "I remember staring out of that window because it looked right over the playground, this 'huge' playground that I was never allowed to go out and play on."

The picture reinforces the foreshadowing. The classroom's tall, wooden windows—shot in silhouette—resemble jail-cell bars. All this sets up a bit of mystery. It tempts the audience to find out more.

CONFLICT

The essence of storytelling is conflict. Something has to be resolved. Ruby faces a mob. Her parents' divorce. Her father's job loss. Conflict aplenty here.

CHARACTER GROWTH

The key to good storytelling is how that conflict changes the characters in your story. They must learn something. At first Ruby seemed unaffected.

> **[NARRATION]**
> **She went to her classroom . . .**

RUBY BRIDGES "And it was empty. (CHUCKLES) So my first thought was, 'I'm too early.' (LAUGHS)"

Ruby saw the world through a six-year-old's eyes. When her father was tossed off the job and her parents' marriage broke up, she was content to step into history's shadow. That changed after her brother was murdered near their old school.

> [NARRATION]
> **Ruby stepped back into the spotlight, determined to help other children who have problems.**

RESOLUTION

Ruby returns to Frantz Elementary School, this time as a teacher herself:

RUBY BRIDGES

"We have to spend a lot more time with our kids, making sure that they are not faced with those same things that this six-year-old was faced with."

The conflict is resolved. Ruby now understands that her role in history is not finished. That sets up the final thought, which summarizes the point of the story:

> [NARRATION]
> **This little girl of six was able to do what she did because her heart and mind were wide open. Ruby's mission today is to keep other hearts and minds from closing.**

PUT STORIES INTO CONTEXT

We all know what is and what ought to be. Many of us don't know what was. Journalists must add that context to every story. With Ruby Bridges, I considered showing the famous Norman Rockwell painting first, then telling her story, but concluded that viewers would start thinking about

the painting. Ruby Bridges is the story, not Norman Rockwell. We had to carefully construct an emotional outline that would make people care about her.

First we showed the audience that Ms. Bridges has a great sense of humor. She's engaging, lovely. This humor softens the tragic story we have to tell. Makes Ruby seem less like a civil rights icon, more like a neighbor. Her humor invites the viewer to watch. Then, we tell them what she endured—a six-year-old, marching through hateful crowds— day after day. Most everyone has been six, so viewers understand how terrible that would be. Next, we toss in a comic sound bite to lighten the mood. Unrelenting sorrow turns viewers away.

RUBY BRIDGES "When I first drove up to the school, I actually thought it was Mardi Gras. (GIGGLES) You know. Living here in New Orleans. The crowd outside. They were barricaded. And they were throwing things. I kinda felt like I was in the middle of a parade."

After that, we could return to serious matters. Here, we shifted the point of view from a child's perspective to a parent's. Told the viewer about the sacrifices Ruby's mother and father made. By now the viewer knows most of Ruby's story. We've shown her ordeal through a child's eyes and a parent's perspective—both universal elements that touch viewers deeply. Only then do we introduce the famous Norman Rockwell picture. The audience may say, "Oh yeah, I remember that." But the painting placed here doesn't overpower Ms. Bridges' story. Viewers are already caught up in it and want to know more.

We end with a twist to make a point. The audience might expect Ruby to make a final plea for tolerance between blacks and whites. Instead, the two little boys she picked to illustrate the need for tolerance are both African-American. One is a bit lighter skinned than the other.

RUBY READING TO GROUP OF SIX-YEAR-OLDS	"It shouldn't matter that Gerald is not the same color as you."
BOY	"No, we're still friends."

That's the essence of Ruby's message. Skin color—regardless of color—should make no difference. The visual surprise helped to drive home that point in a way the viewer was not expecting. In other words, I wrote to the *corners of the picture*, adding details that the audience might miss.

CHAPTER 5

THE BUILDING BLOCKS OF A STORY

ALL visual news stories, whether broadcast on television or on-line, employ a handful of basic building blocks:

- Words
- Video
- Silence
- Natural sound
- Short sound bites
- Graphics
- Reporter on-camera stand-ups
- Logical editing, both visually and verbally
- Surprises

Sometimes video takes precedence, sometimes sound bites or graphics. Depends on the story, but the building blocks from which you choose remain the same.

WORDS

Too many words can stuff a visual story like an overflowing closet. Nothing stands out. Write like a poet, not with flowery words, but with vivid

images that help the viewer remember what you have to say. Think of your story as if it were that closet. Would you pack it full of assorted hangers or fill it with three or four beautiful outfits that will stand out?

In other words, develop three or four main points for each minute of air time. You will never have enough time to say what you would like in a visual news story, so pick a few main points and polish them until they shine. To save time, be hard on yourself as a writer. Say nothing in your script that your viewers would already know or that the visuals say more eloquently.

VIDEO

Throughout the story, build your report around sequences—two or three shots of a guy buying baseball tickets; two or three shots of a husband and wife drinking coffee at the kitchen table, and so on. This will give you more choices when you edit your report and keep it visually interesting. Remember the "Pops Dream" story? What if we only had video from the back of the room of the young man conducting the Boston Pops?

SILENCE

Stop occasionally and let compelling action occur without VOICE OVER [V/O]. For the writer, nothing is more difficult to write than silence. For viewers, sometimes nothing is more moving than that moment of silence. Think of what the "Cave Rescue" story would have been like had we not paused to let the viewer experience the joy of the moment when the injured climber was pulled from the earth? Powerful stories require more than telling what happened.

NATURAL SOUND

Watching news on the Internet or TV is like trying to count boxcars. Too much rattles past us, leaving little impression. How can you get people to pay attention? Use natural sound. A short blast of a horn. A cry of grief. A crowd's roar. Many people listen to TV news. They don't look at it.

They're busy brushing their teeth, fixing breakfast, and checking e-mails. We have no captive audience. No darkened theater. The only one hanging on your every word is you. Natural sound tells the viewers to turn toward the screen and pay attention.

Use natural sound to heighten realism, authenticity, believability; to heighten the viewer's sense of vicarious participation in the events you are showing.

SOUND BITES

Short quotes prove the story you are showing. Don't use long sound bites as a substitute for more effective storytelling.

I never had to ask that sidewalk salesman how he sold enough potato peelers to live on Park Avenue. The natural sound of his brief pitch to passersby showed us why he sold so many: "Now why would you buy four peelers if they last a lifetime? Because you have four friends. That's why."

REPORTER ON-CAMERA STAND-UP [STU]

Whenever possible, try to find a stand-up location that doesn't interrupt the flow. I once did a piece at a baseball field. Decided to shoot my on-camera bridge from the stands during the game. Sat down next to some fans; explained what I had in mind and then waited until someone got a hit so the fans would be cheering and following the play, not staring at the camera.

What do you write in a stand-up? Whatever information you can't visualize; information that transitions from one location to another. I know live shots generally begin and end with reporters on camera, but that can lead to lazy, formula reporting. The number of times a reporter appears on camera will never matter to viewers, if you don't tell them why a story is important to their lives.

Many stories on the web have no reporter on camera. The whole story is told in the subject's words with close-ups and video. What does having the reporter on-camera add to the story? Why is it important to have the reporter be seen? Why did you want your mom to tell you a bedtime story

and not some stranger? You liked the way she told it. You trusted her. She was family. That's an important lesson in communication. If the viewer knows you are the storyteller and trusts your work, it forms a powerful bond. People will return again and again.

GRAPHICS

Graphics are effective to illustrate complex ideas and story points without pictures, but don't overuse them. Find ways on location to illustrate information. Assigned a story on skyrocketing beef prices? Go to the butcher's counter and ask to see some stew meat. Not steak. Meat that most Americans can afford. Take out a five-dollar bill and ask, "How much of this meat could I have bought for five dollars, five years ago?" Then ask how much five dollars would buy now. The butcher takes his cleaver. Whack. He trims away the meat you can no longer afford for five dollars. That patty now looks like an hors d'oeuvre. No spinning numbers or graphics. Gloriously low-tech, yet instantly clear. That's inflation!

Many times in your career, you will be asked to tell a story about seemingly ancient history. How do you help viewers care about your assignment? Knowing how and when to use the building blocks of a story can help you make a story that has been told many times *seem* as urgent as today's headlines. Here's one example of story we think we already know.

SCRIPT #10: PEARL HARBOR'S UNTOLD STORY

ANCHOR
INTRODUCTION:
WE REMEMBER PEARL
HARBOR DAY THIS
MORNING WITH A
SPECIAL *AMERICAN STORY*,
ONE THAT HAS NEVER
BEEN TOLD—UNTIL NOW.
HERE'S BOB DOTSON.

RED BALL OF SUNRISE GRADUALLY FILLS THE SCREEN	**[NARRATION]** **It was a sunrise of fire and the memory still burns.** NAT SOUND: BOMBING	*The sun appears to sizzle, rising out of the ocean. Its color enhances the old black-and-white film footage of Japanese fighter planes raining bombs on the U.S. Fleet in Pearl Harbor.*
JAPANESE PLANES APPEAR. DESTRUCTION OF PEARL HARBOR, HAWAII, BEGINS.	**[NARRATION]** **The sizzling seas sent the United States into World War Two.** NAT SOUND: BOMBING	*The image matches my opening line.*
RED SUNLIGHT REFLECTED IN THE HARBOR	**[NARRATION]** **Before the memory of that day bled away, 110,000 people were arrested in America for what another country did.**	

AUTHORITIES TAKE
PEOPLE FROM THEIR
HOMES, BUSINESSES AND
PLACE THEM BEHIND
BARBED WIRE.

NAT SOUND AND
VINTAGE MUSIC
[NARRATION]
They were plucked
from homes and
businesses and penned
behind barbed wire.
Most looked like the
Japanese who attacked
Pearl Harbor, but in
Hawaii they rounded
up Hawaiian-Americans
too.

JOE PACIFIC

"This man came down.
Showed me a badge.
He say, 'Joe, I gotta take
you down to police,
immigration, to check
your papers.' I say to
him, 'Wait five minutes. I
make a sandwich for my
daughter and for myself.'
He says, 'Naw, you don't
have to do that because
you'll be back in fifteen
minutes.'"

This untold story now
seems as fresh as recent
headlines.

PHOTOGRAPH—JOE AND HIS DAUGHTER	**[NARRATION]** **Joe Pacific was gone four months.**	*This first surprise is placed here to lead the viewer to ask, "What would I do, if that happened to me and my family?"*
JOE PACIFIC	"And they left my daughter alone in that house. All alone. She was there for three days alone."	
PHOTOGRAPH—ALFRED PREIS AND WIFE JANA LAYERED OVER FILM FOOTAGE	**[NARRATION]** **Alfred Preis and his wife Jana were picked up in the first long breath after the bombs.**	
ALFRED PREIS	"We went and were brought down in a darkened city at snake pace. Dead silent. Interrupted by shots from time to time."	*"Snake pace." Pure poetry. Preis is evoking that scary time better than I could write it, so let him tell it.*
HONOLULU IMMIGRATION HEADQUARTERS	**[NARRATION]** **Honolulu Immigration Headquarters: They thought they were needed as translators, Austrians who could speak several languages.**	

ALFRED PREIS

"My wife was taken away and I never saw her for a long time. I felt a cold, sharp object in my back and a voice said, 'Go ahead now,' until I came to a steel ladder or stairway. And he pushed me up with a bayonet. I opened the door myself and found little glowing spots in all different heights. These were bunkrooms and there were people on all layers of the bunks. They were smoking cigarettes."

"... little glowing spots"— another surprise. One that I didn't have to write.

PHOTOGRAPHS OF SYMPHONY CONDUCTORS AND HOTEL CHEFS PAN TO OTTO ORENSTEIN'S PASSPORT

[NARRATION]
The former conductor of the Honolulu symphony was there. So were most of the chefs of Hawaii's great hotels. Even a Jew from Vienna who had escaped a Nazi concentration camp.

Wow. Wow. Wow. Surprise tumbles over surprise. Who knew the roundup of potential spies included a man who just escaped from a Nazi concentration camp?

OTTO ORENSTEIN

"I thought it was a rather unjust thing that first the Germans would intern me, then the Belgians would intern me, now the Americans doing it too. What did I do?"

ESTABLISHING SHOT. BOB DOTSON AND OTTO ORENSTEIN TALKING AT THE SITE OF WORLD WAR TWO INTERNMENT CAMP	**[NARRATION]** **Otto Orenstein had the misfortune of speaking with a German accent.**	
ALFRED PREIS	"A man in uniform demanded that we empty our pockets again. Even took our wedding rings away because he was afraid we would use them to bribe somebody."	*This may be ancient history, but most everyone would wonder, "What would it be like to lose your wedding ring?" This quote becomes the YOU in HEY, YOU, SEE, SO.*
PHOTOGRAPH OF ALFRED AND JANA PREIS AS NEWLYWEDS	**[NARRATION]** **Alfred Preis was a newlywed.**	
ALFRED PREIS	"When they took the wedding ring away from me, I broke down because what went through my mind, 'Not even Nazis would have done that.'"	

OTTO ORENSTEIN
WALKING WITH HIS WIFE
ON THE SITE
OF HIS OLD INTERMENT
CAMP

[NARRATION]
Only a few are left who
can tell the story, an
address list of long-
forgotten names.
NAT SOUND: "Barbed wire
was there."
[NARRATION]
They were herded
onto Sand Island in
the harbor across
from Honolulu with
immigrants from
Finland and Norway as
well.

ALFRED PREIS

"No floors. Cots without
mattresses. Mud on the
ground. So we lay on the
cots and the cots started
to sink and sink and sink.
We virtually, the first
many nights, slept in the
mud."

Prisoners at Guantanamo
Bay have better
accommodations.

BOB DOTSON ON A HILLSIDE ABOVE THE OLD CAMP SITE	**STAND-UP COPY** **The camp got so crowded some people were transferred to detention centers on the mainland. When they pointed out that few Italian-Americans or Austrian-Americans were being held, they were released. But soldiers met them at the gate, transported them back to Hawaii and locked them up again. During World War Two, the islands were under military rule so it was all perfectly legal.**	*Important to explain how this could have happened. The stand-up is the perfect place to do that.*
JOE PACIFIC	"From Sand Island, I could see my house."	
PHOTOGRAPH: JOE PACIFIC'S SHOE STORE	**[NARRATION]** **By the time Joe Pacific was released, someone had stolen all the shoes in his store.**	*Now is the time to tick off what happened to these people.*
JOE PACIFIC WITH A FAR-OFF LOOK	"So close and so far."	

AFRED PREIS AT DRAFTING TABLE. PHOTOGRAPH OF OTTO ORENSTEIN'S FAMILY	**[NARRATION]** **Alfred Preis could not find work as an architect. The Orensteins lost their home.**
BOB DOTSON SPEAKING TO OTTO ORENSTEIN	"Did anyone ever apologize?"
OTTO ORENSTEIN	"Nope. Nobody paid me twenty thousand dollars either . . ."
BLACK-AND-WHITE FILM OF JAPANESE-AMERICANS IN INTERNMENT CAMPS. DISSOLVE TO GRAPHIC OF AMERICAN FLAG SURROUNDED BY THREE FACES: ORENSTEIN, PREIS AND PACIFIC	**[NARRATION]** **. . . as the government did for Japanese-Americans who were sent to such camps. Yet these three—with hearts shot full of pain—continue to love America.**

Narration completes the point Otto is making, saves time and adds context.

ALFRED PREIS ON SMALL NAVY BOAT HEADING OUT TO THE ARIZONA MEMORIAL. HE IS SURROUNDED BY SAILORS WHO HAVE COME BEFORE THE TOURISTS THIS MORNING FOR A RE-ENLISTMENT CEREMONY.	NAT SOUND: BOAT AND FLAG RAISING CEREMONY **[NARRATION] Preis in particular set out to reclaim his patriotism. Not far from his island prison, he offered a simple tribute to those who fell at Pearl Harbor. He is the architect who designed the USS *Arizona* Memorial.**	*Every building block in this story was carefully placed to lead to this last and biggest surprise.*
ONE OF THE SAILORS RECOGNIZES PREIS AND THANKS HIM FOR CREATING THIS ICONIC MEMORIAL.	NAT SOUND: SAILOR THANKS PREIS **[NARRATION] His life, like that war, found victory in defeat.**	*Nine words sum up what Preis accomplished, tying the war and his life in a nice little bow. I simply asked myself, "What did this mean for his life?"*
FINALLY, PREIS IS LEFT ALONE WITH HIS THOUGHTS, WATCHING THE RISING SUN.	NAT SOUND: PREIS IN TEARS **[NARRATION] For *Today*, Bob Dotson, NBC News, Pearl Harbor.**	

http://www.today.com/video/today/57024677

How does this story make you feel? Sad? Mad?

OTTO ORENSTEIN "I thought it was a rather unjust thing that
 first the Germans would intern me, then
 the Belgians would intern me, now the
 Americans doing it too. What did I do?"

ALFRED PREIS "When they took the wedding ring away
 from me, I broke down because what went
 through my mind, 'Not even Nazis would
 have done that.'"

Notice we highlighted these emotions to set up the final amazing surprise. Preis so loved his adopted country, even after all he had been through, that he designed one of its most famous memorials.

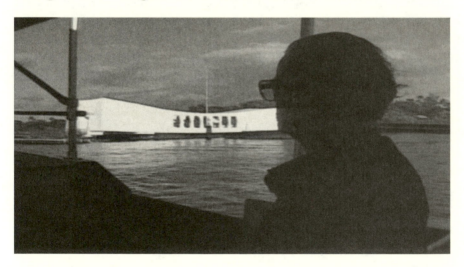

A compelling story needs to emphasize one other universal element—*hope*. Without hope, viewers click away. We run the risk of losing our audience if we fail to offer an emotional human story. They will also tune out if we don't put things into context. Who cares about ancient history? Viewers have enough to worry about. Yet, every year, you will be assigned anniversary stories marking some great event. To survive, you must offer up more than dry memories. Do a bit of investigative work. Find a way to connect the story to today's headlines. Help the viewers care.

EDITING STORIES

Preplanning will save you in the edit room. Before you go out to shoot your story, ask if the segment will run with a graphic banner in the lower third of the screen. If so, make sure you frame your shots accordingly. Who wants to watch a golf ball drop into the banner and wonder if the putt was sunk?

Some people think that if you rewrite, it means you are an amateur. But professionals constantly tweak what they have written. Editing is your best rewrite machine. It's not just where you take out the dull parts. It is where you begin the deliberate process of guiding viewer thoughts and associations. All the building blocks you've gathered—sound, video, information—are of equal value when you're editing. Like a beautiful building, each block has its place. But don't over-produce your piece. Create lovely images with words when you can, but realize the kind of painting that is possible, given the time. Most days you won't have time for a richly textured piece. Whittle down your shooting and your scripting. The economy leaves more time to work on a *few* things—pretty pictures, good natural sound, memorable quotes, clever editing, economical writing and reporting.

A SURVIVAL KIT FOR PROFESSIONAL STORYTELLERS IN THE SOCIAL MEDIA AGE

ANYONE can deliver the news today. All it takes is a cell phone and an upload app. Citizen reporters crowd every big story. It becomes a circus. People applaud those who get to the circus first, posting information, accurate or not. They forget that viewers need facts. Unfortunately, we're all faced with a steady stream of deadlines. The get-it-on competition is so intense, reporters scamper from tweet to tweet, telling bits and pieces. The whole process is so time consuming, storytelling is sometimes the last thing we consider in our workday. It gets scant attention. We're more worried about all those people with cell phones who are beating us to breaking news, so reporters race to find the video civilians have taken and then tweet whatever information is trending. For our country to survive, we must spend more time checking facts and putting them into context so that our audience can understand what's going on. We must become better storytellers.

THE "SO WHAT?" TEST

A trailer home burned down. Such a story fails to meet the "So what?" test. The trailer home burned down because the walls were filled with flammable insulation. *That* describes the larger issue and meets the "So

what?" test. Stories can take on a mind-numbing sameness unless they are put into context. A hurricane hits. "Damage will be in the billions." Tornadoes. "Damage will be in the billions." Damage always seems to top one billion. You can almost see the viewer's eyes glaze over.

Look for the telling detail that makes the story unique. If you're writing, you're watching. The material is all around you. Halifax County, North Carolina, once had a terrible flood. Government media releases said, "Damage in the billions." What does that mean? Well, it means more than those cold numbers would imply. Halifax County had 55,000 people at the time. If the cost of that flood were spread evenly, every man, woman and child would lose $20,000. Now, *that's* a figure to which a viewer can relate. It hits the wallet. That's the price of college tuition or a new car.

"Twenty thousand dollars for every man, woman and child in Halifax County."

You have added something to your story that goes beyond what you can find on Twitter.

"ONE THING IS CERTAIN . . ."

Storytelling is search, not certainty. I always head out with the hope that I'll find a better story just around the bend. Such discoveries aren't easy. I sift through four or five hundred suggestions a month and research about a dozen that look promising. That's the unseen hard work of storytelling.

I don't pitch an idea until I know enough about it that I can state in one sentence what I want the viewer to learn. That's tough, but essential. After all, you're selling a story, not a topic. The *Today Show* executive producer may pick only one out of all those hundreds of ideas.

What's my all-time favorite? The next one. A storyteller never stops searching.

YOU ARE NOT THE STORY

Storytelling begins with how the news affects the *viewers*, not us. We work in a mass medium. You don't need a PhD to turn on TV or search

the net, but some viewers have them. Craft your reports in such a way so as not to insult the intelligence of people who know your subject, but—at the same time—try to make your story fascinating for everyone else. Some will watch because they like your pictures; others because they are interested in the subject. Whatever. Highlight the universal elements—love and hate; happiness and sadness—emotions that interest the broadest group of viewers.

IT'S VIDEO, FOLKS, NOT THE MOVIES

People don't normally watch your stories in a darkened room. They're brushing their teeth, eating breakfast, getting kids off to school; they're cooking dinner; answering e-mails, picking up toys. Your task is to get them to pay attention.

In this age of endless live shots, we have to fill 24 hours with news. That leads to formula reporting. Live open. Voice over video narration. Interview with the mayor. Live tag. "Back to you, Biff. I'm Bob Dotson and you're not."

Formula reporting kills communication. It either puts viewers to sleep or sends them clicking to someone else's news. People want something from your writing—understanding and insight. Look for ways to help your viewers feel something about the story and its subjects. If feeling is present, the story will be memorable. It will stick in the viewers' minds.

A grandmother watching a clip from her old home movies isn't just seeing pictures of her family.

"She sees her father walk through the scenes of her childhood. No longer dead 28 years."

Write to create imagery. Look for little details that can be metaphors for what's happening at a level the viewer cannot see. What image does this create?

"Each morning, the sun slips over the horizon, the paint pot tips and spills, casting its beauty on the people below."

Metaphors can help you instill grace in your writing and provide a bit of dramatic tension.

"Race day dawned still and clear, as if the sky had intended to hold its breath."

Another effective way to create vivid imagery—personalize what you write.

"A friend of mine played football for a school so small that the players changed uniforms at half time and came back as the band."

Also, pay attention to the sound of your writing.

"Yellowstone in winter is a world of fire and ice: a teakettle land of boiling steam and belly-deep snow."

Your ear is the best copy editor you'll find.

"The Old West was a forge, and the pioneers who passed through it had spirits of hammered steel."

Avoid weak, wimpy verbs. "Is" is the dullest verb in the language. Reach for words that say more, that do more, that enhance the copy. One time in Alaska, I covered a sled dog race "on a day so cold you could spit and watch it bounce."

Simply write what you see that others do not. Clarity and accuracy create the foundation of all good news stories. You must write to express, not impress.

BE CONVERSATIONAL

Write the way you speak. When I'm struggling to make something clear, I follow the advice of Roy Peter Clark of the Poynter Institute for Media Studies, and fantasize a conversation with my mom. As Mr. Clark puts it,

if my mother asked me, "What did you learn at City Hall today?" which would I tell her:

"The council agreed to support a project to aid small businesses by giving them low-interest loans."

"Well, Ma, small businesses are struggling, but the city council thinks it has found a way to help them out."

GOBBLEDYGOOK AND CLICHÉS

Rid your stories of these verbal weeds. Gobbledygook confuses people who don't know official jargon. How many times have you heard a firefighter say a burning building is "fully involved?" What does that mean? Is the house having an affair? Also, weed out clichés. There is clarity in clichés, but they say something so succinctly we wear them out. If you can't think of a better image, try twisting a tired old line, as I did for a story set in Yellowstone National Park:

"A fellow by the name of John Colter was the first man to tell the world about Yellowstone. Nobody back east believed his fanciful tales of hot springs and boiling mud. People thought there might be a crystal heaven somewhere out west, but if there was a hell, they said, it was Colter's hell. Even today, few people have seen this great Yellowstone land in winter when hell freezes over."

ACTIVE VOICE

The single most important change you can make to improve your writing is to eliminate the passive voice. Which creates the stronger image?

"A lot of noise was made by the approaching hurricane . . ."

"The hurricane thunders offshore . . ."

Writing in the active voice forces you to think about what is happening now. It produces tighter copy. More interesting stories. Audiences assign a greater sense of urgency to stories written in the active voice.

WRITE IN THREES

Grouping things in threes also can make your writing memorable.

"Red, white and blue."

"Life, liberty and the pursuit of happiness."

"Father, Son and Holy Ghost."

Each has a rhythm, a rhythmic pattern of threes.

HOW TO END A STORY

Find a strong visual close whenever possible. An unforgettable image, video you can't top. Something you can build toward throughout the story. Something that your audience won't forget. Then, like a good poet, help the viewer understand the story's meaning. Summarize the point of the piece with a precise closing line.

A fellow by the name of Ed Panzer reminded me of that. Ed and his four brothers were part of a remarkable odyssey—one hundred thousand children plucked from the slums of New York City and sent west to a new life. Most—like the Panzers—were the sons and daughters of immigrants, found starving and alone, sleeping on the streets. The Children's Aid Society swept them up and shipped them to towns all across the country.

At each stop their arrival was advertised. The kids trooped off the train. Lined up. Couples simply picked the ones they wanted. Orphans were often separated from their brothers and sisters. If an adopted child acted up, he was put on the next train west.

In Tekamah, Nebraska, four of the Panzer boys were chosen. One was not. George, the youngest, clung to his brother Harold. Harold refused to let them take George back to the train. So George stayed. But each of the five brothers went to live on a different farm. One couple wanted to adopt two of them. The brothers refused. They had made a pact to keep their last name so they would never lose track of one another. They did not.

Ed became a doctor. Harold did too. They worked to put each other through medical school. Brother Jack built the hospital where Harold opened his practice. Bob became pastor of one of the largest Methodist

churches in California. And George, the baby whose hug kept the brothers together? They all started him in business. He retired a millionaire.

When Harold Panzer turned 81, he got married—with the help of his brothers. Bob performed the service. Ed was best man.

How can you summarize lives like that? As I said, Ed Panzer gave me a clue. "We've always been close," he said, pointing to his brothers. "We've always been there for each other." I turned that cliché into a closing line:

"The brothers have now, what they had then—each other."

CAR WARS

The first person I met when I joined NBC News was a whiskery little guy named Frank Greene. We were standing on a chilly sidewalk waiting for a crew car to take us to an assignment. Frank somehow managed to maintain a two-inch ash on the cigarette dangling from the corner of his mouth, as he greeted me with one eye squinting through smoke that drifted up his face. "I just want youse ta know one 'ting," he said, his voice a low rasp. "I've been here thirty years and I'll BE here when you're gone!" Frank was nearing retirement. He must have had underwear older than I was.

Coming up through small stations, I had seldom worked with anyone over thirty. Didn't know what to say. Frank wasn't expecting an answer. He was telling me what to expect. "When we go out on stories, I sits in the right front seat." A stiff breeze finally knocked the ash off Frank's cigarette. "I always sits next to the heater." He paused to puff. "The cameraman drives, unless he doesn't want to. Then, the electrician drives. Otherwise, the electrician—who we call 40-watt, cuz he's usually a dim bulb—he sits in the back seat on the hump." Another puff. Frank smoked Camels. Once he lit a cigarette, it stayed in the corner of his mouth until he took it out to light another. Frank glanced at the crew car garage. No sign yet of our ride. He continued, "The producer always sits in the back left seat, behind the driver, so he can flick 'em on the ear and tell 'em to turn right or left."

A small smile. "You? Reporters sit in the right rear seat."

He wiggled his index finger. "Don't crowd 40-watt."

The crew car pulled to the curb. Frank popped into the front seat next to the heater. "Welcome to Cleveland," he said, pointing to my place in back.

This was the first time that I had ever worked with a guy who cared more about heat than TV. At noon I learned he cared about food, too. "Hey, Dotson," he rasped. "Youse got ten more minutes!"

"Ten minutes until what, Frank?"

"Ten minutes, den I'm pulling my audio plug and sittin' in da car until we go to lunch."

We were filming children on a playground. True to his word, ten minutes later, Frank yanked his audio line from the back of the camera and left. I looked at cameraman Cliff Adkins. Cliff shrugged.

"Well," said Cliff. "At least Frank waited until we got a minute's worth of audio in the can. No one can fault him for not doing his job."

I looked around glumly. "Yeah, but what are we going to do?" Was this the end of my big-time career?

"Do you want to drive Frank nuts?" asked Cliff.

I grinned. "Sure."

"He's going to expect one of two things," said Cliff.

"Either we yell at him when we go back to the car or we give him the silent treatment."

I nodded. Made sense.

"If you really want to drive him crazy," said Cliff, "let's act like nothing ever happened."

"How will that drive him crazy?"

"You see, he wants to pick a fight so he can file a union grievance," Cliff said. "That'll take him out of the cold for days while the grievance sorts itself out. Meanwhile, he'll be warm and get lunch on time."

"Why doesn't he just talk to the managers who assign the story? It's not our fault he's working through lunch."

"He's afraid," said Cliff. "It's easier and safer to take out his frustration on us."

"Great," I sighed.

"Well, let's do it," said Cliff. "Let's pretend as if nothing ever happened, but you have to promise me one thing."

"What's that?"

"You've got to talk to the assignment editor and remind him that Frank needs his lunch on time. Food and heat are important when you're over sixty." Cliff grinned, but he meant it.

We finished our shooting, then walked back to the crew car. Frank was hunkered in the front seat, next to the heater.

Engine running.

"Hi, Frank!" I said. "Hey, where do you want to go eat?"

Two weeks later, we worked together again.

We met on that same chilly corner. Frank was pacing back and forth.

"Hi, Frank—"

"All right!" Frank growled. "What's goin' on!"

"Going on? What, Frank?"

"How come youse never yelled at me?"

"Yell at you, Frank? Why?"

"You know why!"

"Well," I said. "I thought you made a good point about missing lunch, so I talked to the assignment editor when I got back to make sure you didn't miss any more."

"You did?"

"Yeah."

"Oh."

Frank Greene was not our best audio guy. He was known for letting the needle ride in the red. Didn't pay much attention to over-modulation. But, from that day forward he got better when he worked with me. I always made sure to highlight Frank's sound in my stories. If he climbed down a hill to get sound of a rushing river, I would pause in my narration to let the sound play.

Gradually, grudgingly, we became friends.

My wife, Linda, was five months pregnant at the time.

The day she flew from Oklahoma to join me in our new home, I met her at the airport with Frank and the crew. We were on our way to Cincinnati, assigned to do a *Today Show* story. Would she care to fly along in the Learjet?

"What's another plane ride?" said Linda.

Off we went.

When we arrived in Cincinnati, 40-watt pulled the rental car alongside the plane. Frank hopped out and opened the car door. The front passenger door.

"Mrs. Dotson," he motioned. "Would youse like to sit next to da heater?"

The next morning, over coffee, Cliff Adkins shook his head.

"I've worked for 13 years with Frank Greene and I've never seen Frank give up the heater. Not even for a pregnant NUN!"

"Cliff," I asked, "why is it we are paid because we communicate clearly with thousands of people every day, but we can't seem to talk to the guy sitting next to us in the crew car? It's so important that each of us work well together because the end result is a group effort. Seems to me the water walkers who sign paychecks don't know good audio from bad or great camera work from home video. All they say is, 'That story wasn't wonderful.'"

"We seldom work well together," said Cliff, "because we blame everyone else while overlooking our own failures. I say, 'My story would have been an award winner, but you wrote wall-to-wall narration.' You say, 'Hey, Cliff, your shots are shaky and the audio is unusable.' Remember, Bob, the only person you can change is you. You want to get better. Make yourself better by helping others to be better, too. People who help you survive in this business are not always the most pleasant. Don't waste your life waiting to work with the 'best' or cursing your fate when faced with a 'Frank Greene.'" Frank became a good friend and we made each other better than we thought we could be.

Think of this business as a rough-and-tumble football game. View life like a broken field runner. Change when you see an opening. Then, try to make yourself one of a kind. You might not get every assignment you want, but someday, someone will say:

"We need a Bob Dotson story."

Some day they will think of you—first.

A FINAL THOUGHT

We all have bad hands dealt to us every day, because shorter deadlines and increasing story counts have us working faster and longer. Just remember—success in this business does not depend on being dealt a good hand. It's playing a bad hand well, over and over again.

APPENDIX

Reporter's Checklist

I HOPE you found some ideas in this book that make it worth its price. In closing, I pass along my "Reporter's Checklist," questions I ask myself during every assignment:

☐ How can I make this a compelling story with universal values that appeal to a wide audience?

☐ Where can I find a strong opening, preferably a visual lead that instantly telegraphs the story to come?

☐ Is my writing strong, tight and free of information that people already know?

☐ Does the story build to a close?

☐ Are there elements of surprise with the visuals or sound to attract and hold viewers?

☐ Is the subject matter interesting, concrete, important—not just another fluff piece?

☐ Does my piece meet and answer the "So what" test? Does it contain historical perspective that defines the story's larger context? Does it address a larger issue?

☐ Is my story told through people engaged in compelling action that is visual or picturesque? Does the report let people tell their own story whenever possible?

☐ Did I let the camera "talk" for itself whenever possible?

☐ Is my camera work steady? Do I have creative treatment of content and composition; interesting angles; minimal use of pans and zooms? How well does my camera work meet professional and creative standards?

☐ Are my on-camera appearances, if any, used appropriately and not used to substitute for more compelling elements of the story?

☐ Do my stand-up [STU] appearances deliver information that helps drive the story forward?

☐ Are my voice over [V/O] narrations delivered with authority, spontaneity and feeling? Are they tight, active voice, understandable, readable and listenable?

☐ Does the sound track carry meaning that can help viewers create secondary visual images (subtext)?

☐ Is my audio crisp and clean? Am I using wild sound and background sound and sound bites to break up long narration?

☐ Is the music, if any, appropriate to mood and content?

☐ Is my lighting natural? Can I use available light? Does it highlight what I want the viewer to notice?

☐ Does my editing give the story pace? Am I building the story in a logical sequence? Does it cut smoothly from wide shot to close-up? Am I cutting on action? Do my sound tracks overlap smoothly? No dead air? Do I have video or graphic to cover everything I need to say?

GLOSSARY
OF SCRIPT CUES

CUTAWAY: A cutaway interrupts the video action by inserting a view of something else, usually followed by a cut back to the shot that was previously seen.

LIVE SHOT WITH CORE VIDEO: Reporter appears live on camera to open and close story shot on location; LIVE WRAP for short.

LIVE WRAP: Short for LIVE SHOT WITH CORE VIDEO [LWC].

NATURAL SOUND [NAT SOUND]: Recorded on location as part of the video action.

PAN: Moving camera from side to side, usually following action.

STAND-UP [STU]: Reporter faces camera and speaks directly to the audience.

TILT DOWN OR UP: Moving the camera lens up or down.

TWO-SHOT: Two people are framed in the camera's viewfinder.

VOICE OVER [V/O]: Narration over video action.

ACKNOWLEDGMENTS

WRITING is a solitary profession. Television is not. Many talented journalists work with me on my stories and help to shape them.

A special thanks to those whose efforts are highlighted on these pages—Stephanie Becker, Jim Bell, John Hyjek, Ned Judge, Rob Kane, Amanda Kinsey, Debbie Kosofsky, Tom Mazzarelli, Don Nash, Dave Riggs, Cathy Romine, Laurie Singer, Lauren Specter, Jim Thompson, Jim Townley, Alex Wallace, Amy Wasserstrom, Bill Wheatley, Craig White, Jeff Zucker. I also appreciate the thoughtful comments and suggestions provided by Rowman & Littlefield's developmental reviewers: Barry Catlett (University of North Texas), Keren Henderson (Syracuse University), Ryan Parkhurst (James Madison University), Joe Sampson (Miami University of Ohio), Judd Slivka (Missouri School of Journalism), and Steve Sweitzer (Indiana University–Purdue University Indianapolis).

I also want to thank Professor Fred Shook, my lifelong friend and mentor, whose advice still guides my work and echoes throughout these pages.

Finally, I thank NBC News for taking a chance on a kid with red hair and freckles and sticking with him until his hair turned gray.

Bob Dotson
New York

INDEX

active voice, 123

Ades, Joe, 64, 72. *See also* "Park Avenue Peeler" script

Adkins, Cliff, 126, 128

American Story with Bob Dotson, 1–2. *See also* script examples

back story, 34

beginning stories: at beginning, 30; with pictures, 83–84

Berner, Scotty, 4–6

bookending stories, 71

Bridges, Ruby, 89. *See also* "Ruby Bridges" script

camera: CUTAWAY, 93; LIVE WRAP, 85; panning, 20; reporter on-camera LIVE WRAP, 85; reporter on-camera stand-up, 59,

105–6; story pace and moving, 66; TILT DOWN, 62; TILT UP, 33; two-shot, 23. *See also* reporter on-camera stand-up

"Cave Rescue" script, 89; foreshadowing in, 87; notes leading to, 85; text, 85–88

characters: finding strong central, 63–64; growth of, 96, 98–99

Clark, Roy Peter, 122–23

clichés, 123

cliffhangers, segment, 89

closing stories: finding closing line, 38; in "Living Ghost Town," 81

conflict, in stories: in long-form story structure, 96; in "Ruby Bridges," 98

context, of stories, 116; of "Ruby Bridges," 97, 99–101

CUTAWAY shot, 93

details: pointing out, 61; unique stories with telling, 120. *See also* writing, to corners of picture

drama, natural, 88

editing: as building block of stories, 117; of "Ruby Bridges," 89, 97; of "YouTube Star," 52

emotion: finding quotes that compel, 14; human stories with, 116; underscoring, 69

ending stories, 124–25

establishing shot, 71

"Farm to Fame" script: HEY, YOU, SEE, SO in, 38–39; humor in, 9, 31, 33; surprises in, 29, 33, 38–39; text, 30–38

file video, 69

filling the silence, 4

foreshadowing: in "Cave Rescue," 87; in "Found Art," 58; in "Lives Lost," 7; in "Living Ghost Town," 74, 78, 80; in long-form story structure, 96; in "Ruby Bridges," 98

"Found Art" script: foreshadowing in, 58; overview, 56; text, 56–62; writing to corners of picture in, 56, 57, 59, 60

Frost, Robert, 14

Gibbons, Corky, 97

gobbledygook, 123

graphics: in "Ruby Bridges," 97; as story building block, 106

Greene, Frank, 125–28

headlines, story, 33, 34, 35

HEY, YOU, SEE, SO story outline: cutting video and, 44, 46, 50; in

"Farm to Fame" script, 38–39; overview, 17–18; in "Pops Dream" script, 18, 19, 27; visual story structure and, 39; writing story middle first and, 84; in "YouTube Star" script, 39, 47

hope, in stories, 116

humor, in stories: in "Farm to Fame," 31, 33, 39; in "Lives Lost," 9; overview, 39

Ideas Notebook, 85

images: pre-planning, 12; writing imagery, 121–22

imagination, starting stories with, 55

interviews: finding interesting people to, 72–73, 82; after interview tip, 14; looking for articulate people to, 63–64; making interviewee comfortable, 13–14; most important tip, 13–14; rule of three answers, 4; silence in, 4. *See also* quotes

jokes, setup, 61

Jonesboro girls shooting, 15; "Lives Lost" script about, 6–13

Kane, Rob, 97

Kaplitz, Bob, 64

Lindsey, Kyle, 39. *See also* "YouTube Star" script

LIVE SHOT WITH CORE VIDEO (LWC), 85

"Lives Lost" script: foreshadowing in, 7; humor in, 9; overview, 6; text, 7–13

LIVE WRAP, 85

"Living Ghost Town" script: closing story in, 81; foreshadowing in, 74,

78, 80; natural sound in, 78, 79; Non-Question/Question in, 81; overview, 72–73; surprises in, 76, 80; text, 73–81

long-form reporting, 1. *See also* long-form story structure

long-form story structure: character growth, 96, 98–99; conflict, 96, 98; foreshadowing, 96, 98; overview, 96; resolution, 96, 99; of "Ruby Bridges," 96–101; scene setting, 96–97; segment cliffhangers, 89

LWC. *See* LIVE SHOT WITH CORE VIDEO

music, transitions, 68

narration: natural sound and, 78, 86; quotes and, 52; in "Ruby Bridges," 97; in "YouTube Star," 52

natural drama, 88

natural sound (NAT SOUND), 7; depth and nostalgic, 71; in "Living Ghost Town," 78, 79; narration and, 78, 86; in "Park Avenue Peeler," 67, 71, 72; in "Ruby Bridges," 97; script tightening using, 69; as story building block, 104–5

NBC News, 1, 125

Non-Question/Question: in "Living Ghost Town," 81; overview, 4–6

notes: capturing thoughts in, 84–85; Ideas Notebook, 85; leading to "Cave Rescue" script, 85; "YouTube Star" script planning, 39–44

opening line: writing a good, 14–15; writing story middle before, 84

Orenstein, Otto, 116. *See also* "Pearl Harbor's Untold Story" script

panning, 20

Panzer brothers, 124–25

"Park Avenue Peeler" script: natural sound in, 67, 71, 72; overview, 64; text, 65–72

"Pearl Harbor's Untold Story" script: response to, 116; story building blocks in, 106, 115; surprises in, 109, 110, 116; text, 107–15

people: being curious about ordinary, 72; finding interesting, 72–73, 82; looking for articulate, 63–64

pictures: matching words to, 60, 65; writing stories beginning with, 83–84. *See also* images; writing, to corners of picture

"Pops Dream" script: HEY, YOU, SEE, SO in, 18, 19, 27; text, 18–27; unexpectedness in, 28

Preis, Alfred, 116. *See also* "Pearl Harbor's Untold Story" script

punch line, building to powerful, 70

questions, in stories: answering, 37; memorable quotes and thoughtful, 70. *See also* Non-Question/Question

quotes: finding compelling emotion, 14; getting unique, 4; narration and, 52; Non-Question/Question and unique, 4–6; paraphrasing opening line from second best, 14–15; picking, 14, 32, 49, 77; thoughtful stories and memorable, 70; transitions using, 77; usage in "YouTube Star" script, 49, 51, 52, 53. *See also* sound bites

reporter: on-camera LIVE WRAP, 85; storyteller compared to, 2

reporter on-camera stand-up, 59; as story building block, 105–6

reporting: formula, 121; storytelling and, 2, 3–4. *See also* long-form reporting

resolution, of stories: in long-form story structure, 96; of "Ruby Bridges," 99; of "YouTube Star" script, 43

"Ruby Bridges" script: character growth in, 98–99; conflict in, 98; context of, 97, 99–101; editing of, 89, 97; foreshadowing in, 98; four-shot sequence, 97; graphics in, 97; long-form story structure of, 96–101; narration in, 97; natural sound in, 97; overview, 89; resolution of, 99; scene setting of, 96–97; text, 89–95; writing to corners of picture in, 101

rule of threes, 4

scene setting, 73; in long-form story structure, 96–97; of "Ruby Bridges," 96–97

script: three-column format, 6; tightening using natural sound, 69; two-column format, 6

script examples: "Cave Rescue," 85–89; "Farm to Fame," 29–39; "Found Art," 56–62; "Lives Lost," 6–13; "Living Ghost Town," 72–81; "Park Avenue Peeler," 64–72; "Pearl Harbor's Untold Story," 106–16; "Pops Dream," 18–28; "Ruby Bridges," 89–101; "YouTube Star," 39–54

silence: filling the, 4; in interviews, 4; as story building block, 104

social media age, professional storytelling: active voice, 123; being conversational, 122–23; crew and cars in, 125–28; ending stories, 124–25; gobbledygook and clichés, 123; overview, 119; "So what?" test, 119–20; story searching, 120; viewer-focused, 120–21; writing imagery, 121–22; writing in threes, 124

sound bites: story building block of short, 105. *See also* quotes

"So what?" test, 119–20

speakers, professional, 4

stand-up (STU), 9; copy, 75; location choice, 70; reporter on-camera, 59, 105–6

starting stories: different ways of, 55–56; "Found Art" script, 56–62; with imagination, 55; with interesting stories and interviewees, 72–73, 82; "Living Ghost Town" script, 72–81; "Park Avenue Peeler" script, 64–72; with strong central character, 63–64; by writing to corners of picture, 55–56

stories: back, 34; bookending, 71; closing line, 38; about everyday life, 82; headlines, 33, 34, 35; hope as universal element of, 116; layers of, 14; memorable quotes and thoughtful, 70; moving camera and pace of, 66; opening line, 14–15, 84; playing bad hand well, 128; theme, 8; unexpectedness in, 28; viewer experience of, 14

story building blocks: editing, 117; graphics, 106; natural sound, 104–5; overview, 103; in "Pearl Harbor's Untold Story," 106, 115; reporter on-camera stand-up, 105–6; short sound bites, 105; silence, 104; surprises, 103; video, 104; words, 103–4

story points: in middle of story, 84; one sentence summary, 83; proving visually, 83

storyteller: curiosity and imagination, 2; reporter compared to, 2

storyteller, becoming: after interview tip, 14; "Lives Lost" script, 6–13; most important interview tip, 13–14; Non-Question/Question, 4–6; overview, 1–3; reporting vs. storytelling, 3–4; rule of threes and filling silence, 4; writing good opening line, 14–15

storytelling: ancient, 1, 3; reporting and, 2, 3–4

structure, story: of visual stories, 39. *See also* long-form story structure

STU. *See* stand-up

surprises, in stories: in "Farm to Fame," 29, 33, 38–39; in "Living Ghost Town," 76, 80; overview, 28–29; in "Pearl Harbor's Untold Story," 109, 110, 116; as story building block, 103; in "YouTube Star," 39–42

theme, 8

TILT DOWN, 62

TILT UP, 33

Today Show, 1

transitions: using music, 68; using quotes, 77

twists and turns. *See* surprises, in stories

two-shot, 23

unexpectedness, in stories, 28

video: file, 69; LWC, 85; as story building block, 104; tools, 97

video, cutting: for HEY, YOU, SEE, SO story outline, 44, 46, 50; for "YouTube Star," 44, 46, 50, 53

viewer: experience of story, 14; focused storytelling, 120–21

visual stories, telling: overview, 1; tight writing in, 3; about what's unseen, 57, 60. *See also* storyteller, becoming

visual story structure, 39. *See also* long-form story structure

VOICE OVER (V/O), 12, 104

"what if" game: cutting video, 44; "Farm to Fame" script, 29–39; HEY, YOU, SEE, SO story outline, 17–18; humor, 39; overview, 17; planning notes for YouTube segment, 39–44; "Pops Dream" script, 18–28; structuring visual story, 39; surprises, 28–29; "YouTube Star" script, 45–54

words: matching pictures to, 60, 65; as story building block, 103–4

writing, tight, 3

writing, to corners of picture: in "Found Art," 56, 57, 59, 60; overview, 55–56; in "Ruby Bridges," 101

writing stories: asking what story means, 84; beginning with pictures, 83–84; capturing thoughts in

notes, 84–85; "Cave Rescue" script, 85–88; highlighting natural drama, 88; one sentence summary on point of, 83; "Ruby Bridges" script, 89–95; working fast, 89; writing middle first, 84. *See also* long-form story structure

"YouTube Star" script: cutting video for, 44, 46, 50, 53; editing of, 52; HEY, YOU, SEE, SO in, 39, 47; narration in, 52; planning notes for, 39–44; quote usage in, 49, 51, 52, 53; resolution of, 43; surprises in, 39–42; text, 45–54

the extraordinary in ordinary lives. He has crisscrossed this country, four million miles, practically nonstop, searching for people who are virtually invisible, the ones who change our lives, but don't take time to tweet and tell us about it.

His reporting has taken him around the world where he is an acclaimed documentary producer. His program, *El Capitan's Courageous Climbers* (NBC Productions), was the winner of seven International Film and Video Festivals and was awarded documentary's highest honor, the CINE Grand Prize.

Back home he wrote and hosted *Bob Dotson's America*, a series of programs on the Travel Channel. His last book, *American Story, a Lifetime Search for Ordinary People Doing Extraordinary Things*, became a *New York Times* best seller.

Today Show.Com—Bob Dotson's American Story
http://www.today.com/news/tag/american-story

Twitter
http://twitter.com/bobdotson

Facebook
http://www.facebook.com/nbcamericanstory

ABOUT THE AUTHOR

NBC News correspondent Bob Dotson has done it all in his long career—camera, sound and editing. He's been a writer, producer and reporter. He's covered politics, sports and breaking news. Now he hosts the *American Story with Bob Dotson*, his signature series on the *Today Show*.

Dotson's work has received more than a hundred honors, including eight national Emmys, a record *six* Edward R. Murrow Awards for "Best Network News Writing" from the Radio Television Digital News Association, and most recently, the William Allen White Foundation's 2015 National Citation for long-standing journalistic excellence in service to the profession and community.

Bob's stories reflect his rare approach to the news. He works the neglected corners of our cities, the small towns and dirt roads, seeking